Heracles
The Twelve Labors of the Hero
in Ancient Art and Literature

Heracles
The Twelve Labors of the Hero
in Ancient Art and Literature

Frank Brommer

Translated and Enlarged by
Shirley J. Schwarz

Aristide D. Caratzas, Publisher
New Rochelle, New York
1986

Thanks are due to the following sources for illustrative material used:

Foto Marburg: Plates 7, 8, 15, 17, 19, 20, 34, 47; Deutsches Archäologisches Institut, Athens: Plates 9, 10, 29, 44; Marburg Archeological Seminar: Plates 13, 14, 24, 33, 40, 42, 43, 45; British Museum: Plates 3, 11, 21, 37: Kassel: Plate 6; Jena: Plate 12; Munich: Plates 18, 27, 30, 31, 38, 39, 41; Würzburg: Plate 22; Madrid: Plate 46; Oxford: Plate 23; Ny Carlsberg Glyptothek: Plates 25, 26; Private Collection: Plate 32.

Aristide D. Caratzas, Publisher
Caratzas Publishing Co., Inc.
P.O. Box 210, 481 Main Street
New Rochelle, New York 10802
Brommer, Frank.
 Heracles: the twelve labors of the hero in ancient art and literature.

 Translation of: Herakles.
 Bibliography: p.
 Includes index.
 1. Heracles (Greek mythology)—Art. 2. Arts, Classical. I. Title.
NX652.H4B7613 1986 700'.938 83-21057
ISBN 0-89241-375-1

Printed in the United States of America

Contents

List of Figures vii

List of Plates ix

Preface xi

I Myth 1

II Heracles 3

III The Twelve Labors 7

IV The Cycle of the Twelve Labors 55

V The Transformation of Heracles' Image 65

Notes 69

Appendix: Greek Texts 83

Bibliography 89

List of Abbreviations 95

Index 99

Plates 105

List of Figures

1. Map of Region of Heracles' Labors.
2. Olympia: Shield Band. After drawing by H. Schleif. Kunze, *Archaische Schildbänder*, 11, no. V, pl. 21.
3. Philadelphia, Private Collection: Fibula
4. Breslau: Corinthian Aryballos.
5. Athens, Acropolis: Hydra Pediment. Buschor, *Grössenverhältnisse*, p. 12, fig. 8.
6. Philadelphia, Private Collection: Fibula.
7. Vienna, Kunsthistorisches Museum 1841: Attic Black Figure Lekythos.
8. Location Unknown: Corinthian Alabastron.
9. London, British Museum E539: Attic Red Figure Oinochoe.
10. Three Figure Relief. After drawing by H. Götze.

On title page Berlin Museum F336: After a proto-Corinthian aryballos.

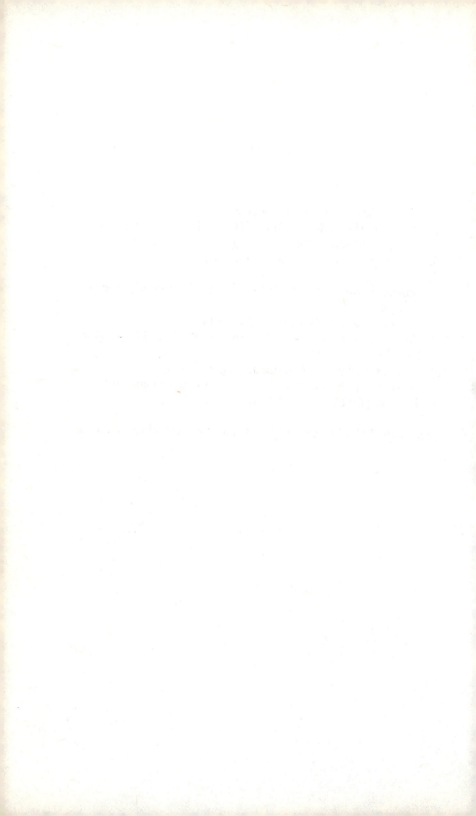

List of Plates

1. Olympia: The Metopes of the Temple of Zeus. *Olympia, Ergebnisse* III, pl. 45; Hege-Rodenwaldt, *Olympia,* fig. 26.
2. Athens, Hephaisteion: The Metopes. Sauer, *Das sog. Theseion,* pl. VI.
3. London, British Museum 3204: Fibula.
4. Athens, Cerameicus: Terracotta Stand.
5. Samos, Museum: Spartan Cup.
6. Kassel, Museum T 384: Attic Black Figure Amphora.
7. Delphi: Metope from the Athenian Treasury.
8. Delphi: Metope from the Athenian Treasury.
9. Olympia: Metope. Heracles Head.
10. Olympia: Metope. Lion Head.
11. London, British Museum 3205: Fibula.
12. Jena: Corinthian Cup.
13. Berlin F 1801: Attic Black Figure Cup.
14. Leningrad B 4257: Attic Red Figure Oinochoe.
15. Athens NM 325 (B76): Attic Red Figure Cup from the Acropolis.
16. Olympia: Shield Arm Band. *2. Olympia-Bericht,* pl. 32. After drawing by Professor Geibel.
17. Berlin F 2034: Attic Black Figure Pyxis.
18. Munich 2003 (J 355): Attic Black Figure Mastos.
19. Athens NM 43: Relief.
20. Delphi: Metope from Athenian Treasury.
21. London, British Museum B 231: Attic Black Figure Amphora.
22. Würzburg 199: Attic Black Figure Neck Amphora.
23. Oxford 1934.333: Attic Black Figure Plate.
24. Paris, Louvre G 263: Attic Red Figure Cup.
25. Copenhagen, Ny Carlsberg Glyptothek: Geometric Oinochoe.
26. Copenhagen, Ny Carlsberg Glyptothek: Geometric Oinochoe.
27. Munich 1842: Attic Black Figure Lekythos.
28. Syracuse 14569: Attic Black Figure Lekythos.
29. Olympia: Metope.
30. Munich 1407: Attic Black Figure Amphora. *CVA.* Munich, pl. 37.
31. Munich 1379: Attic Black Figure Amphora. *CVA.* Munich, pl. 13.

32. Adolphseck, Private Collection: Attic Red Figure Krater.
33. Nauplia, Museum: Votive Shield from Tiryns. *BSA* 42 (1947): pl. 18.
34. Berlin F 1710: Attic Black Figure Amphora.
35. Berlin F 2263: Attic Red Figure Cup. After drawing in *Berliner Apparat* 22, 108.
36. Location Unknown: Corinthian Cup.
37. London, British Museum 65.7-20.17: Proto-Corinthian Pyxis.
38. Munich 2620: Attic Red Figure Cup.
39. Munich 2620: Attic Red Rigure Cup.
40. Würzburg 472: Attic Red Figure Cup.
41. Munich 1493: Attic Black Figure Amphora.
42. Athens NM 1132 (CC 957): Attic Black Figure Lekythos. *JdI* 57 (1942): 109, fig. 3.
43. Berlin Inv. 3261: Attic Black Figure Lekythos. *JdI* 57 (1942): 109, fig. 2.
44. Nauplia, Museum 136: Attic Alabastron, *JdI* 57 (1942): 114, figs. 8-10.
45. New York, Metropolitan Museum 24.97.5: Attic Red Figure Hydria.
46. Madrid, Museum: Mosaic from Leiria. *JdI* 37 (1922): 1.
47. Athens, Acropolis Museum: Heracles Head from the "Olympus Pediment."

Preface

Modern discussion of the legend of Heracles has been based primarily on the literary sources of antiquity. Few ancient sources have been discovered in recent decades, and such literary sources have always contained less information than pictures.

The amount of information from pictorial representations of Heracles has been much enlarged. In the area of vase painting alone our knowledge has increased considerably owing to recent discoveries.

We know with fair accuracy when and where these vessels were created. They provide us with a fuller account of the Heracles legend. Studying this legend, we should therefore take into account both literary and artistic sources. This book is an attempt to fill that need.

We may hint here at two conclusions that emerge from the treatment of this material: with the aid of pictorial representation we can push back by centuries the origin of certain legends—further than the literature alone might suggest. The time gap between these myths and their oriental prototypes is narrowed considerably.

The question of how these oriental legends arrived in Greece has not yet been adequately answered; it must be left to other scholars. Yet it is incontestable that at least the Hydra fight and the Hind adventure had their prototypes in the Orient. These two deeds belong to the few Greek legends that can be proven to originate as early as the eighth century B.C. The similarity between oriental and Greek pictures here cannot be accidental.

S.J. Schwarz

I
Myth

Myths were formed long before the earliest Greek writings known to us. They go back further than the Homeric epic poems of the eighth century B.C. In this early period myth was not just one of the various possible forms of expression; it was the most important one. Myths were not deliberate artistic creation; they arose from instinctual feelings. They were not conscious interpretations in the sense of allegories—but the world was seen in that epoch exclusively in terms of myth. Myths were valid not only for a part of the population but for everyone.

Today fairy tales are not believed by the mother who narrates them—they are believed only by the child listening to them. Both narrator and audience, however, believed in the myths they told and were told. This unity explains the power of myths, which encompassed many aspects of life and which exerted their power for generations of listeners.

For a fabulist such as Aesop, thinking came first and writing second; pure myth, on the other hand, does not recognize this split between writer and thinker. It sings in thought, and it thinks in the form of song. Moreover, myth in its day was the only form of dealing with the past; and it was presumably the most elaborate form of experiencing the present. When myth came into being there existed no art, no philosophy, no history, and no scholarly or scientific work; myth functioned for all of these. When the world of myth dissolved, these disciplines and forces were set free, and the heroes of various myths began to acquire lives of their own in secondary worlds. The lives of mythic heroes became more removed from their origins. [1]

Myth in daily life and the study of myth are mutually exclusive; and they belong to different stages of the develop-

ment of mankind. As long as genuine myth is alive, there can be no study of myth. The moment scholarly examination comes into being, genuine myth can no longer survive. There can be no returning to it.

Critical reason does not play a role in the development of myth, but it is essential for examining myths. Scholarly study of myth can only be undertaken if it can separate itself from the fantasies that it examines. Even intuition freed from intellectual analysis is only possible after scholarly study, if the realm of fantasy is to be avoided. Still, students of myth in a period long after myth has ended can only approach myths by analysis. The student can, by traveling back to the earliest possible period of myth, trace its development in literature and art and arrive at an intuitive sympathy with myth makers.

By this process certain events about which we have little information can be understood. Such a procedure, however, to some extent distorts the myths it studies because myths are not tied to any one fixed moment. A student may explore a mythic event, but his study can reveal little of the essence of myth.

To approach myth by way of reason is like measuring color differences with a ruler. Nevertheless, we can use only that yardstick given to us. The proper way of judging a myth is lost to us; but, in fact, it never existed. Those who lived before the study of myth never attempted to quantify or judge it; they were immersed in it, they were under its spell. Only after gaining distance from myths could they consider them with an eye toward doubt or reason. But at that moment myth no longer existed.

II
Heracles

In Greek mythology Heracles stands out as one of the most important figures. By the eighth century, i.e., in the earliest surviving illustrations different exploits of Heracles are already represented. Centuries later vase paintings, metopes, and sculptures, as well as numerous other monuments of different sorts illustrate his deeds. He is a source for literary inspiration, i.e., epos and tragedy.[2] For three thousand years he has inspired artists. Not simply a man, he was the son of Zeus, the highest of all gods. He was, moreover, not simply a god, for the mortal queen Alcmene was his mother, while his twin brother Iphicles descended from the mortal father Amphitryon. Yet when Heracles died, he arrived in Olympus and was received by the gods who relied on him heavily in their fight against the giants. They could not win without him.

Heracles' extraordinary deeds start shortly after his birth. Pindar writes:

I cling with confidence
to Heracles
on the great peaks of excellence,
reviving an ancient story
of how, laborlessly released from his
 mother's womb, this son of Zeus
saw glorius light immediately
with his twin; but

not without the notice of Hera
(gold-enthroned) did he wear his infant's
 saffron;
and the queen of the gods,
feeding her rage, sent sudden serpents:
and these slid down

through opened doors into the room's
expanse, ready to coil the boys
to lightning-swift jaws; but Heracles
raised his head and was the first to fight,
taking and twisting with his
sure hands the throats of the serpent pair;
and time removed the breath
of life from their monstrous strangled forms.
Now, the women attending
Alcmene's bed were beaten by a fear
they could not bear;
but she herself leapt unrobed to her feet
ready to challenge the monsters' assault.

And quickly in crowds the Cadmeian
captains ran
up with drawn bronze;
and Amphitryon, waving
a naked sheathdrawn sword, came,
clutched with piercing care—for personal
distress debilitates a man,
while the heart is shortly free of care
where strangers are concerned.

He stood, amazed, and
mixed his dread with joy; for he saw
the miraculous spirit and strength
of his son: the gods had reversed the words
of his messengers.
He summoned a neighbor then, the
eminent prophet of the most exalted Zeus,
truesighted Tiresias, who told him and
the others there the chances the child
would take,

the number of beasts he would kill on land,
the number of savage sea-beasts he would slay,
and said the child would
bring to death the one who slithered in
treacherous insolence,
the man most hated by men, and
added that, when the gods on the

Phlegran plain should fight
the Giants, the volleys of his arrows
 would down the Giants and earth would
 darken their glowing hair,
but that he, through all
 time's transit,
in peace
would be released
from great troubles' pains and, in the Home
of Happiness, choose and receive sweet
 Hebe as consort in marriage
and, dining with Zeus, son of Cronus,
would praise august ordination.[3]

In the first moments of Heracles' life, the dangers, efforts, perilous exploits, and audacious deeds of a hero begin as announced in Pindar's poem by the seer Tiresias. We know so many deeds of Heracles, that from his birth to his death and ascent to Olympus, we could write a complete biography.

Twelve of his deeds stand out. These were collected in ancient times in a popular series called the Dodekathlos. The most famous and at the same time the earliest pictures from the entire Dodekathlos are the metopes on Zeus's temple at Olympia. Each of the twelve metopes depicts one deed in relief (pl. 1). This temple, dedicated to the highest god, harbored the most famous sculpture of ancient times, the colossal statue of Zeus made by Phidias of gold and ivory. That Heracles was celebrated on a temple not dedicated to him demonstrates his importance, an importance that persisted from the Archaic period to shortly before Classical times. Among preserved Archaic pediments there are few without Heracles, even though they come from buildings dedicated to other deities. Where there is a story to tell, Heracles is a favorite. He thrives in the fantasy of Archaic artists no matter what building, vessel, or bronze plate they are working on.

It is no accident that we encounter on a mosaic (pl. 46), coins, tombstones, and relief vases the same twelve deeds five hundred years after Olympia. The question then arises when the Dodekathlos and each of the twelve stories developed.

Not only literature of ancient times but also monuments of

art tell us about Heracles. Apart from the pediments, friezes, and metopes of temples, and apart from a few free-standing sculptures which have been preserved, we obtain most of our information about Heracles from the abundant artifacts of minor art: bronze reliefs, gems, statuettes of clay and metal, coins, and—most importantly—vase painting.

The sixth and even the seventh century give us several important pictures from non-Attic regions, especially Corinth but also Sparta and Ionia. Most representations of Heracles' deeds, however, were made on Attic black figure vases between 550 and 500. Attic red figure vase pictures are of comparatively minor importance; they too were made to a large extent in the last decades of the sixth century. In the fifth century, Athens continues to provide us with more illustrations on vases than other regions. In the Classical period, though, the popularity of Heracles themes diminishes; such themes belong essentially to the Archaic period. In the fourth century, the number of pictures of Dionysiac subjects surpasses that of Heracles. In fact, by this period interest in mythology had significantly diminished. The number of themes becomes limited, and interest in scenes of everyday life increases. Portrait sculpture, for example, displays a new interest in the individual, in his emotional life. Also in the Hellenistic period, pictures of Heracles play a comparatively minor role. During the Imperial period, however, we find a renewed interest in Heracles, but the reason is not a resurgence of belief in myth; it is a connoisseurship of a myth, a mythologizing.

The early pictures are particularly important, for they trace the legend of Heracles back several centuries before the earliest preserved literature. These early pictures are closest to the real world of myth, and for this reason we shall concentrate on them.

III

The Twelve Labors
of Heracles

1. The Nemean Lion

The order of the twelve deeds varies depending upon the
literary or pictorial source. Generally the lion adventure is
considered the first. It is certainly the most frequently repre-
sented of all the deeds; it is indeed the most frequently repre-
sented theme in all of Greek art. For the period from the mid-
sixth century to the mid-fifth century alone there are hundreds
of Attic vase pictures with this theme, and new finds and
publications constantly increase this number.

According to all ancient sources the lion killed by Heracles
lived in Nemea (fig. 1). According to pictorial evidence, this
lion was killed in a fight at close quarters. Heracles attacked
him with a club or sword and then strangled him. Again and
again the hero and lion are depicted in combat either standing
or lying. The numerous pictures of this theme differ from one
another only in minor details. In all probability there existed a
legend which explained the weapon as well as the strangulation
and according to which Heracles originally tried to slay the
lion with a sword; when he recognized the lion could not be
killed with bronze he began to strangle it.

Time and again the composition is the same. An Attic black
figure amphora now in Kassel (pl. 6) which belongs to the
second half of the sixth century is characteristic. Heracles
grasps the lion from behind with his left hand and opens the
lion's mouth. His right hand pushes the sword into the animal's
neck[4] The fighting group is framed by a female figure to the left
and by an approaching warrior to the right, apparently Iolaus,
the faithful companion of the hero in numerous pictures.

Approximately the same composition can be found on an
earthenware stand, again of Attic origin, from almost two
centuries earlier (pl. 4). On the amphora the unclothed hero is

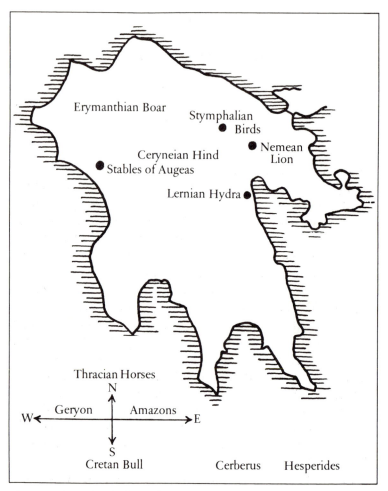

Fig. 1. Region of Heracles' Labors

distinctly different from the armed warrior of the framed frieze on the Cerameicus stand in plate 4. On the stand he fights with a sword in his right hand and with a lance in his left. This is the lance we see Iolaus carrying on the amphora. The scene on the eighth-century stand must be interpreted mythologically. If it is a representation of a myth then the hero is probably Heracles.[5] At any rate, the lion adventure surely belongs to the earliest represented deeds of Heracles. The reason is not so much Heracles' popularity in Archaic times as it is the incontestable fact that oriental prototypes are the

source for this motif (as they are for the Hydra motif). If the Hydra adventure and several other deeds are already found in the eighth century then the fact that the Nemean Lion is found this early should not surprise us. However, in the early period the lion slayer did not always have to be Heracles. Perhaps it is also Heracles we see on the right panel next to the rosette of the bronze fibula from the same century (see pl. 3),[6] although the hero there defeats the lion not with a sword but with a spear. Since we can recognize a Heracles deed on the left panel of this fibula, we may interpret this scene as the lion combat.

The gap between the Geometric epoch (pls. 3, 4) and the Archaic representations (pl. 6) may be bridged by terracotta reliefs from Sunium[7] and by bronze shield bands (fig. 2).[8] Individual panels from the shield bands were decorated with pictures of various popular legends. In one panel (fig. 2) the bearded and unarmed Heracles tries to strangle the lion, which is depicted in the manner of many other such compositions on armor. Thus, we have three types of representations: Attic, as seen on the clay stand; Boeotian, as seen on the early fibula; and the Peloponnesian, as seen in the bronze reliefs.

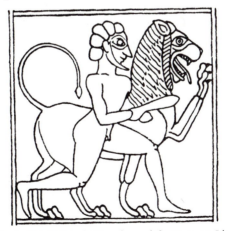

Fig. 2. Shield band. *Heracles and the Nemean Lion*

Another work of Peloponnesian art, a Spartan cup, depicts the hero fighting the lion by using a similar strangle hold (pl. 5). A horizontal line divides the inner picture of this cup into two unequal parts so as to give the main group a ground line.

The smaller field is filled with two cocks, the upper one with the lion combat. The armor of Heracles, the cuirass and greaves, is characteristic of warlike Sparta. Only the missing helmet tells the viewer that Heracles is not just another noble mortal warrior. Snakes, birds, and ornaments enliven and confuse this picture of the powerful strangling, in which the lion's mouth is forced open in pain. It is a more archaic scene than that represented on the Attic amphora (pl. 6) where the figures stand freely before the background.

Monumental art of the Archaic period also depicted the theme of Heracles and the lion.

The treasury built by the Athenians in Delphi about the late sixth to early fifth century displays deeds of Heracles on several metopes. One of them is reserved for the lion combat (pl. 7). The metope, as an inherently closed and compact composition in late Archaic times, demanded a concentration upon essentials. For this reason the artist omitted subsidiary figures. Here the picture closely resembles that of the earlier amphora (pl. 6) made several decades earlier. With this amphora in mind we can complete the missing parts of the metope. In the relief, we find the hero's costume, bow, quiver, and club in place of accompanying figures. Thus the artist fills the empty space and makes identification of the hero certain. The fight on the metope is just as fierce as on the vase, but owing to his erect posture, Heracles seems more powerful.

The few Archaic monuments we have discussed (pls. 5, 6, 7) must represent a large number of preserved pictures. They do illustrate the typical element of this theme. We might imagine the representation on the throne of Amyclae mentioned briefly by Pausanias (3.18.15) as similar.

The metope from Olympia (pl. 1, 1; pl. 9) represents something quite different. It was made only a few decades after the Athenian treasury—perhaps as many years as the Athenian treasury (pl. 7) was constructed after the Kassel amphora (pl. 6). Nevertheless, the interpretation of the Olympia metope is entirely different from that of all earlier monuments.[9] For the first time the theme is not a battle, not an action: it is a reflective, calm situation. The lion is defeated. It is stretched out on the ground. Its head rests on a paw; its eyes grow dim, its tongue

hangs limply from its slightly open mouth (pl. 10). Although the hero stands above the beast, he shows no sign of triumph. The ferociousness of the struggle as expressed in the Archaic period by wrestling or strangling or by the vividly excited gestures of the bystanders has changed; instead the victor props his head on his hand in a pensive and tired attitude. Heracles appears in this first deed without a beard; he is youthful. All other metopes of Olympia represent him as a mature man. These efforts of his left their mark on him (pl. 9).

Unlike artists before him, the artist of the Olympia metope did not represent the external event but the internal drama. Individual psychological experience replaces physical wrestling. This new attitude and interest can be seen for the first time on the Olympia metope, and much evidence suggests that this psychological interest first manifested itself in Olympia. The choice of this moment tells us that here the archaic attitude has been abandoned.

Other less pioneering artists continue to work in traditional ways. The creator of the metopes of the Hephaisteion in Athens (pl. 2), for example, did not follow this original creation of the Olympia master. As late as Roman times, more than half a millenium after the Olympia metopes, we still encounter in mosaics and on other monuments the old battle scheme and the moments after the battle. The aftermath scenes may have as their prototype the Olympia metope; we assume so especially because we have at Olympia a cycle of twelve episodes (a Dodekathlos) (pls. 1, 1; 9; 46).[10]

2. The Lernian Hydra

We are able with high probability to trace the lion combat back to the eighth century. We can do so with certainty for the Hydra adventure. The Hydra legend appears early in Greece;[11] we must not rule out prototypes adapted from the orient. In fact, the similarity between pictures on oriental seals and early Greek representations is so apparent that it cannot be accidental. It is possible that this legend existed in the orient an entire millenium before the earliest Greek depictions.[12] Identification of this legend is not certain. Nevertheless, it seems likely that the Greeks adopted at least the external form of oriental composition.

Hydra, according to Hesiod in his *Theogony* (313 ff.; see 2 p. 00), is the third child of Typhon and Echidna:

> And third again she bore
> the grisly-minded Hydra
> of Lerna, whom the goddess
> white-armed Hera nourished
> because of her quenchless grudge
> against the strong Heracles.
> Yet he, Heracles, son of Zeus,
> of the line of Amphitryon,
> by design of Athene the spoiler,
> and with help from warlike
> Iolaos, killed his beast
> with the pitiless bronze sword.[13]

The multiheaded Hydra lived in the swamps of Lerna (fig. 1). After Heracles decided to fight her, his old foe, Hera, who had once sent snakes into his cradle, sent a crab which increased the difficulty of the Hero's combat by biting his leg. "Against two, not even a Heracles can have the upper hand," says a Greek proverb. Heracles, therefore, asked the aid of Iolaus, and with arrows, sickle, and torch the two attacked the monster. For each snake killed, two new heads grew forth; thus, they had to cauterize the wounds they made as they inflicted them. In this way they killed the monster.

Greek literature is rarely as uniform in reporting a legend as

it is here. From first to last, the pictures adhere to the literary sources. Only the number of snake heads varies. The precise number of heads never mattered much, however; the idea was to show a multitude of them. In a single play, one Greek author mentions two different numbers of heads; one vase painter draws a different number of heads on two sides of the same vessel. The difference obviously was not important for the artist. Literature is even freer than art in varying the number of heads, since the latter is more limited by its pictorial nature. Generally, the Hydra has nine snake heads.

As with the lion combat, the earliest picture appears on a Boeotian fibula of the eighth century B.C. (pl. 11).[14] In the picture to the left of the rosette, we find all the elements of the legend. The many-headed Hydra confronts Heracles while the crab bites his foot. The diminutive Iolaus hurries to help and wields a torch and serrated sickle.

The identification of Heracles on the earliest lion combat representation is questionable (pls. 3, 4) because the possibility exists that another unknown mythological or mortal figure may be fighting. The Hydra representation, however, leaves no room for doubt (pl. 8). No Greek hero other than Heracles fought the Hydra; no monster but the Hydra can be intended, and later representations agree with the elements we find in the earliest picture.

Another artist of the eighth century engraved a more regular, almost rectangular plaque (fig. 3).[15] He placed the two heroes at the edges of the plaque and the Hydra in the center with her heads striking out to both sides. The hero on the right is apparently Heracles; we can be sure because the artist did not forget the crab between his legs. Heracles grasps a snake head with one hand while wielding his sword with the other; he has already cut off one head, which can be seen below the sword. To the left Iolaus attacks the monster with a sickle.

Another fibula from the seventh century depicts the Hydra combat.[16] In that century, the first vase painters, from Corinth, illustrate the same theme. Of all important centers of vase production, Corinth is closest to Lerna, the home of the legend.

Such Corinthian vase pictures differ from fibula images in only one aspect. On vases the painters depict a chariot used by

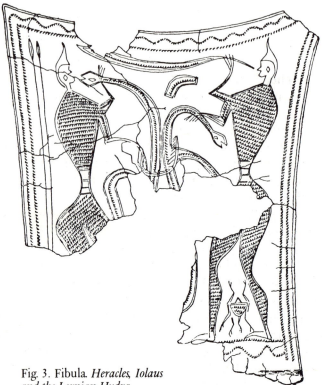

Fig. 3. Fibula. *Heracles, Iolaus and the Lernian Hydra*

the heroes. Sometimes they show two chariots, the second for Athena (fig. 4, pl. 36). On one picture (pl. 12), Heracles first uses his arrows before fighting the Hydra at close quarters. One of the arrows can be seen in the body of the monster. Except for this detail, the main group with the Hydra in the center, flanked by the two heroes and the crab, does not differ from the drawing on the fibula plaque (fig. 3). Even the weapons, the sword and sickle, remain the same.

On a Caeretan hydria in a private collection, Iolaus attacks the nine-bodied Hydra from the left and Heracles attacks from the right. The latter wears a cuirass and greaves in order to protect himself from the crab. The unbearded Iolaus closes in on the monster with a sickle,[17] Heracles with a club.

The preserved Attic vase representations of the Hydra combat begin in the first decades of the sixth century just at the time Corinthian vase production ceases. A particularly beauti-

ful vase painting can be seen on a little Master cup (pl. 13). A light strip reserved in the dark background of the exterior of the vessel encircles the cup, displaying the Hydra fight on both sides with considerable vividness and care. The master avoided tedium by representing only the main group of the fight. The signature of the artist fills the empty space. Iolaus and the crab are missing, and Heracles fights the Hydra alone with his sickle. Some snake bodies are already limp; others are turned viciously against the hero. Unafraid, Heracles fights with determination and energy, as we can see from his stance. On the other side of the Hydra stands a female figure: either Athena, the protectress of Heracles, or the local nymph, Lerna. Her white body and red dress enliven the fine, careful composition.

Representations on an Attic bowl made several decades later—also black figure—are much cruder.[18] Again the scene appears on both sides of the vase; again Iolaus and the crab have been omitted, but the female figure is present and can, in this case, be clearly identified as Athena. In both pictures the Hydra is coiled around the tree. On one side of the vase Heracles attacks with a club; on the other he holds something out to the Hydra—a substance of some sort—which he holds cradled in his right arm. We can explain the picture only in this way: Heracles appears to paralyze or at least to distract the snake with food—a version of the legend we see in neither literary nor other pictorial sources.

Heracles and the Hydra also appear on an amphora of Euphronius in red figure technique made about the same time as the vessel mentioned above. The ornament on one side of the neck of the Euphronius vase is still in old-fashioned black figure technique but that on the other side demonstrates the new technique. The pictures on the belly are entirely in red figure and, although they belong together, are distributed over both sides. Heracles aims his arrow at the Hydra, which is coiled around a tree. The protagonists, who are freely distributed over the large space, are represented in a monumental figure style and therefore do not need detailed description. Iolaus and the crab are therefore absent.

The inner picture on a cup pieced together from many fragments (pl. 15) also belongs to the Archaic period. Heracles,

Fig. 4. Corinthian Aryballos.
Heracles and the Lernian Hydra

his quiver around his shoulder, is wielding a large sickle in his right hand against the Hydra, who loses large amounts of blood. The painter was clever in filling the round area; Iolaus would not have fitted into this composition. Therefore the artist made the pliable body of the snake occupy the right part, while club and crab filled the left. Heracles' right leg constitutes the central axis of the picture and forms a diagonal with his left leg. As he bends forward his upper torso forms a diagonal to the right.

After the few fragmentary red figure representations of the Hydra combat from the fifth century, we are surprised to discover another illustration from the fourth century, for such depictions of Heracles are then extremely scarce. The elements of representation (pl. 14) are almost the same as those of four hundred years earlier (fig. 3, pl 11): Heracles and the Hydra fighting, Iolaus with the torches. The crab is omitted, and Heracles brandishes a club instead of a sickle. But more changes—changes of content—have taken place. The gigantic, terrifying monster with her bodies twisted around her enemies becomes a weak being, one which Heracles and Iolaus defeat without much effort. Clearly, by this time the myth had lost its impact.

In monumental art, representations of this legend start about the same time on Attic vases, namely in the first decades of the sixth century. Pausanias reports a group showing the Hydra fight made of iron by Tisagoras and dedicated at Delphi (Paus. 10.18.6). Unfortunately, we know neither how it looked nor when it was made. From among the architectural, sculptural, and ceramic "Persian debris," buried in the reconstruction of the Acropolis in 480 B.C., we have fragments of a red figure cup (pl. 15) and a flat pediment of a small, unknown building (fig. 5). The most important figure, Heracles, occupies the center of this pediment. The gigantic Hydra occupies the entire right

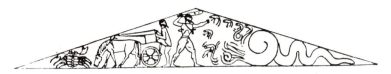

Fig. 5. Pediment of the Acropolis.
Heracles, Iolaus and the Lernian Hydra

half, cleverly filling the corner with her winding coils. The heroes, as on Corinthian vessels (fig. 4, pl. 36) which date from the same time or a little earlier, arrive in a chariot. The master of the pediment shows Iolaus with Heracles and uses the crab to fill the corner. The monster, clearly different from the crabs in vase paintings of the fourth century (pl. 14), is rendered in all its horrifying size and danger. We cannot tell from the picture (although we know it from the myth) whether he will win the contest. The bigger the monster, the more imposing must be Heracles' victory.

The Hydra metope of the Athenian treasury in Delphi is unfortunately so poorly preserved that we cannot include it in this discussion.

The metope from Olympia (pl. 1, 2) is next in chronological order. Unfortunately, it has been almost entirely destroyed. Here we see a representation similar to that of the lion metope of the same temple (pl. 1, 1; 9). It is, in comparison to earlier pictures (figs. 3, 4; pls. 11, 12, 13, 15, 36) a new interpretation: it focuses on the essentials. Iolaus and the crab are missing. Similarly, the Hydra, as in a good many vase pictures, coils parts of her body around a tree and is close to giving up. Some of the snake bodies hang down limply. As in the representation of the Nemean lion, we have here a later phase of the combat than the one represented in earlier pictures.

On the other hand, the metope on the Hephaestus temple (pl. 2, 2) uses the earlier fashion despite its later date. Iolaus joins Heracles, thus almost breaking the frame of the metope, while the Hydra offers more resistance than her counterpart in Olympia.

Each master solves problems of composition differently. All the details in the representations, however, agree with the literary reports and are consistent, except for minor discrepancies.

From the Hellenistic period on, the Hydra may have a

human head.[19] This interpretation is especially popular in the Imperial period; it may be reflected in a remark of Apollodorus, who mentions the eight mortal and one immortal heads of the Hydra.

3. The Erymanthian Boar

In the Erymanthus mountains (fig. 1) lived a wild boar, which Heracles had to catch, immediately after killing the Hydra, to present alive to King Eurystheus. Only a few literary sources after the fifth century mention this legend. Diodorus is the first to report that when Eurystheus saw Heracles approach carrying the boar on his shoulders, he jumped full of terror into a storage jar, a pithos.

This adventure appears about a century before the first literary mention. There are no vase paintings of this deed, in contrast to the lion and Hydra combats, before the mid-sixth century.

Some Attic vase paintings show the capture of the boar, such as that on a small box from the late black figure period in the beginning of the fifth century (pl. 17). Heracles has caught up with the boar, has forced it to its knees, and is about to lift it to his shoulders. Other paintings display him carrying the animal, as do reliefs—for instance, the one from Athens found near the Theseion in 1839 (pl. 19). In most cases Heracles carries the boar on his shoulders, as he does here; sometimes he holds it by its hind legs, almost in the way we hold a wheelbarrow when we push it.

The majority of the vases and other pictures do not represent him carrying the boar; they show the hero's arrival at King Eurystheus' court. One such scene can be found on an iron arm band from a shield. It came, like the bronze band showing the lion combat (fig. 2), from the recent German excavations in Olympia (pl. 16). It was made in the same period which produced most of the representations of this adventure, i.e., the sixth century. Heracles arrives at Eurystheus' palace after the king has jumped into one of the storage vessels. Only the king's head and his raised arms protrude. Heracles threatens Eurystheus by holding the boar above his head. It is this composition which so many vase paintings and even the earliest known example of monumental art, a metope of Foce del Sele, represent.[20] The metope from Olympia (pl. 1, 7) shows this same moment: that of the Hephaestus temple (pl. 2, 4) differs only in that still more of Eurystheus has disappeared into the ground

and that the boar hovers more closely above the king's head.[21]

We might be tempted to interpret these pictures, particularly the vase paintings, humorously; but that was certainly not the intention of the Greek artist.[22] It is unimaginable that a humorous scene should have entered monumental art; why should just this episode of the Erymanthian boar on the twelve metopes of Olympia have a different character? The importance of this deed lies in its consequences: that even King Eurystheus could be terrified by this boar attests to the power of the animal and Heracles.

In fact, for a long time wild boar hunts played an important role in Greek myth. The Calydonian boar hunt is one example; Theseus defeating the sow of Crommyon another. Thus, the strong boar of Erymanthus was worthy of such a hero as Heracles. Moreover, this is the only adventure of Heracles in which the king appears; and it is the earliest known depiction of Eurystheus in the boar scene among all pictures from the middle of the sixth century until the Roman period (pl. 46). No doubt the seizure of the boar must have belonged to those deeds required by King Eurystheus. Up to now, however, there has been no evidence that this legend is as old as those of the lion and the Hydra.

4. The Ceryneian Hind

Accounts of this legend vary. The earliest reference is found in Pindar. In his third Olympian ode, written in 476 B.C., he sings:

> Then it was the urge took him to journey
> to Istrian country. There Leto's daughter, the
> runner with horses,
> received him when he came from Arkadia's
> ridges and winding gullies,
> when, at Eurystheus' command,
> the doom of his father had driven him
> to bring the doe with the golden horns
> that once Taygeta had written in fee
> to be sacred to Artemis Orthosia.[23]

Pindar tells us that Heracles had to wander from Arcadia to the far north in order to capture the Hind for Eurystheus. We are not told whether he has to bring the animal back dead or alive. Nor do we know for certain if this is the Ceryneian Hind. But the pursuit of the Hind is unique to Istria.

In the same century Euripides writes in his *Heracles* (375 ff., p. 87), "Then he killed the Hind with the golden antlers and spotted hide, the she-robber of the fields whose death the goddess of Oencë will enjoy."

This source clearly announces the killing of the animal. The Hind is a harmful animal which must be slain just as the lion or the Hydra. We are not told specifically if this is the Hind of Ceryneia (fig. 1).

Diodorus' description (4.12.13, see p. 85), however, contradicts Euripides' description:

> The next command which Heracles received was the bringing back of the hart which had golden horns and excelled in swiftness of foot. In the performance of this Labour his sagacity stood him in not less stead than his strength of body. For some say that he captured it by the use of nets, others that he tracked it down and mastered it while it was asleep, and some that he wore it out by running it down. One thing is certain, that he accomplished this Labour by his sagacity of mind, without the use of force and without running any perils.[24]

Despite the slightness of this reference, numerous interpretations come to mind, and none of them agrees with Pindar's version; they all contradict Euripides. We still do not know if Diodorus is referring to the Ceryneian Hind or where Diodorus would place the animal's home. The most detailed account of this adventure comes from Apollodorus (2.5.3. see p. 85).[25]

> As a third labour he ordered him to bring the Cerynitian hind alive to Mycenae. Now the hind was at Oenoë; it had golden horns and was sacred to Artemis; so wishing neither to kill nor wound it, Hercules hunted it a whole year. But when, weary with the chase, the beast took refuge on the mountain called Artemisius, and thence passed to the river Ladon, Hercules shot it just as it was about to cross the stream, and catching it put it on his shoulders and hastened through Arcadia. But Artemis with Apollo met him, and would have wrested the hind from him, and rebuked him for attempting to kill her sacred animal. Howbeit, by pleading necessity and laying the blame on Eurystheus, he appeased the anger of the goddess and carried the beast alive to Mycenae.[26]

It seems as if Apollodorus has tried to combine the two principal literary versions which discuss killing the animal and capturing it.

The golden antlers of the Hind are the only feature reported by all ancient writers.

How does the pictorial tradition view this adventure? The earliest picture is once again found on a Geometric fibula (fig. 6).[27] The Hind wears antlers, as we are told in the myth. Nevertheless, the animal is female, as her fawn reveals. Heracles chases her with his spear. Apparently the fibula maker knew a version similar to that of Euripides. Because the Hind adventure does not serve to identify Heracles as easily as the Hydra exploit, we have to look at the reverse of this fibula. Since there we definitely see another labor of Heracles (namely, the Hydra fight, fig. 3), we may confidently identify the hunter of the Hind here as Heracles.

The next picture of the Hind story was made in Attica almost two centuries later, after the mid-sixth century (pl. 21); Archaic vase paintings outside Attica have not been preserved. Heracles has caught the animal and is breaking off her golden antlers. This version is without parallel in literature or in the

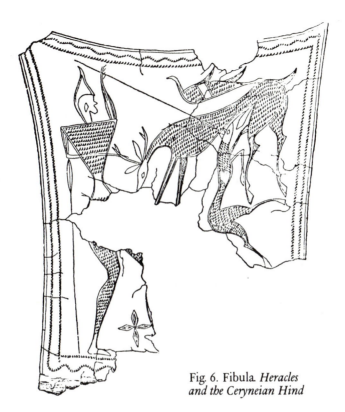

Fig. 6. Fibula. *Heracles and the Ceryneian Hind*

pictorial tradition. Everything seems to take place in a peaceful way without killing or wounding the animal. Athena, the protectress of Heracles, and Artemis, the protectress of the Hind, participate in the action.

The capture of the Hind is depicted on another Attic black figure vessel made somewhat later (pl. 18). Here also there is no killing or wounding and no spear or sword. The club seems necessary only to identify Heracles.

The representations can be contrasted with several vessels which depict a quarrel about the Hind between Heracles and Apollo. The earliest of these depictions, on a plate painted in Athens before the mid-sixth century (pl. 23), shows Heracles with his bow drawn and aimed at Apollo, who is also armed with a bow. Apollo's sister, Artemis, stands between the two opponents trying to negotiate and mediate. The Hind has no antlers, and for this reason this must be a version of the legend other than those in the monuments we previously discussed.

Another related scene is found on a black figure amphora in Würzburg made at the end of the sixth century (pl. 22). The quarrel is illustrated in the same way as another adventure of Heracles, his quarrel with Apollo over the tripod. Various vase pictures belonging to the same period, i.e., the end of the sixth century, resemble the Würzburg picture.

Monumental art of Etruria also employed this theme in a terracotta group of the same epoch. This is the famous group of Apollo from Veii.[28] Minor Etruscan artists took up this theme too. The Hind is usually fettered; we cannot tell whether it is alive or dead. On the Würzburg vessel, Apollo tries to snatch it away from Heracles, who fends him off; Athena sides with her protegé, Artemis with her brother.

These pictures are so numerous and unmistakable that a conflation between this legend and the one concerning the dispute over the tripod can be ruled out.[29] The pictures, therefore, represent a version of the legend which did not survive in literature. Apollodorus most closely approaches this version. According to him, however, Heracles was opposed by Artemis and not Apollo. Monumental art from the Archaic period, on occasion, represents Apollo with the Hind without reference to Heracles.[30] If, therefore, we see Apollo and Heracles quarreling over a stag, it must not be the Ceryneian Hind.

Red figure pictures of this legend are quite rare. One of the few can be found on a cup in Paris (pl. 24). Heracles overwhelms the Hind without arms. He presses the antlers down, apparently in order to fetter the animal and carry it away. As far as we can see, he does not use the bow carried by his companion.

This motif is similar to that on the metope of the treasury at Delphi (pl. 8), whose lion metope (pl. 7) we mentioned before. On the Hind metope, as well as on the somewhat later cup, Heracles presses his left knee against the hindquarter of the animal and grasps its antlers. The hero's muscular athletic body has been rendered in the careful late Archaic manner; it covers much of the picture field. The scene on the cup enables us to complete the composition on this metope, which is devoid of secondary figures and is in a fragmentary state. One large circle can be drawn from the right foot of Heracles through his leg, body, head, and arms, through the antlers of

the Hind, down its neck and body. This composition follows the rectilinear format of the metope, leaving the center free.

Chronologically, the next example of monumental art[1] is again a metope: that from Olympia (pl. 1, 5). Unfortunately, it is in bad condition, yet we can see that as far as the motif is concerned it is very similar to the metope at Delphi. Again the group consists of only Heracles and the Hind. The hero sets his knee on the hindquarter of the Hind and holds its antlers. The composition, however, is entirely different; it does not form a circle but a powerful triangle.

The composition of the metope of the Hephaisteion (pl. 2, 3) is closer to that of the Athenian treasury. If it is true that on metopes of the fifth century the Hind is a male, it is a version of the legend with no parallel in literary tradition.

The pictorial representation of this legend contributes nothing to clarify the ambiguous and partial stories we have in literature. On the contrary, they complicate the situation. More than in other cases, we have to wait and hope for new finds which may explain how this legend developed. Up to now, this seemingly familiar legend is in reality fairly obscure.

5. The Stymphalian Birds

The Stymphalian birds, which built nests near Lake Stymphalus (fig. 1), ravaged the fields and were considered a plague. King Eurystheus ordered Heracles to eliminate them.

According to the earliest testimony, that of sixth and fifth century writers,[32] he did so by scaring them away with a rattle. But there also must have been another version of the myth at that time. The representations, however, suggest that Heracles actually killed the birds.

The contradiction between dead and living birds was solved by Apollodorus in the same way he resolved discrepancies in the tale of the Hind: by compromise. In his version, Heracles first scares the birds away in order to kill them.

The few surviving pictures represent solely the killing; two of these pictures are from the eighth century, the Geometric Period.

The first of these is found on a fibula we discussed before in talking about the lion fight (pl. 3).[33] Heracles and Iolaus hold the birds by their necks. The representation on the shoulder of the jug from the eighth century confirms that this is an adventure of Heracles.[34] On the jug a man—none other than Heracles—on the outermost left border holds a bird by its neck, evidently in order to kill it. Other birds have been frightened away and fly in front of him (pl. 25).

A gap occurs, for not until almost two hundred years later did the next representation appear (pl. 27). In content and interpretation, however, it resembles Geometric pictures, and we have here a situation similar to the case of the two lion combat pictures (pls. 4 and 6) which are alike in content even though chronologically far apart. Evidently a compositional typology, which in oriental art may reach back into even earlier times, survived without much change. Heracles and his smaller companion Iolaus have each caught a bird to strangle or kill with sticks. No doubt their ultimate goal is to kill the birds and not merely to frighten them. The same act can be seen on the few other black figure pictures that we have. Red figure vases with this adventure have not survived.

In figure 7, on a lekythos, Heracles' intention to kill the birds

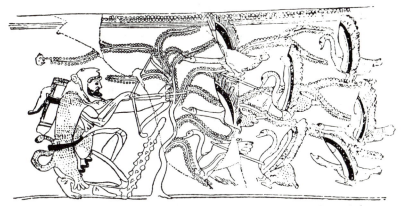

Fig. 7. Attic Black Figure Lekythos. *Heracles and the Stymphalian Birds*

is far more obvious: he shoots his bow toward the flying birds, having encountered two already.

The earliest representation in monumental art is on the metope at Olympia.[35] In view of its good condition and the lack of vase paintings of the Stymphalian birds from the fifth century, this metope is particularly welcome (pl. 1, 3). Again we note the differing interpretation of the Olympia master. The birds have been handed over to the goddess Athena, who in this adventure never appears, either in literature or in art, except in this representation. The artists of the Archaic period show this deed as a wild chase with strangling, beating, shooting, flying, and dying. This wild action would have been inappropriate for the solemn, reserved character of the Severe style. As with the lion combat, the emphasis is on Heracles *after* the fight. Here, however, we see not the subdued and tired hero but the proud victor who, with raised head, hangs over the dead bird, proof that he has accomplished his mission. If this labor was performed in the service of Eurystheus, it is strange that the birds were not handed over to him. Probably the artist took liberties with the content of this story for the sake of composition. On the metope at Olympia Heracles is never alone but always with his enemy or his goddess, or with both together. Hydra, Bull, Hind, Amazon, Horses, and Geryon are considerable opponents; clearly these small birds are not so formidable. Possibly for this reason and without other justification the artist introduces Athena here. Even if this assumption

is wrong, there is no doubt that the metope master determined that he wanted the myth portrayed in new form. His accomplishment is all the more unusual since the theme of the Stymphalian birds was rarely treated in art. It does not appear on the metopes of the Athenian treasury or the Hephaisteion in Athens. The Olympia metope is not only the earliest preserved record of this legend in monumental art; it is also the only one from the fifth and fourth centuries.

According to the description of Pausanias (7.22.7) the roof of the Artemis temple of Stymphalus displayed the Stymphalian birds. He could not determine if they were made from wood or plaster, and he does not mention Heracles.

The Roman mosaic from Leiria (pl. 46) also depicts the killing of these birds.

The few literary sources up to the Hellenistic period mention only that Heracles scared the birds away; the few pictures, on the other hand, represent only the killing. Therefore, it may have been that literature developed its own version independently from the pictorial tradition.

6. The Stables of Augeas

Augeas was a king from Elis (fig. 1) in whose stables large amounts of dung had accumulated. Heracles was ordered to clean these stables. To do so he directed the river Alpheus through them and the water carried the filth away.

The fact that the phrase "an Augean task" has crept into our language might seem to indicate that the legend was popular in antiquity, yet such was not the case. From among thousands of Greek vases which have survived not one represents this deed of Heracles. This adventure is also missing on the Archaic shield bands which enlarge our knowledge of early Greek legend so greatly. Greek art and literature before 475 B.C. do not once hint at this legend.[36]

The earliest reference to it can be found in a poem by Pindar (*Ol* 10, verse 27 ff., see p. 86), written after 476 B.C.: "Heracles wanted from Augeas the money which Augeas did not wish to pay." There is no indication here that Heracles wanted money for cleaning the stables. We do not even learn from this report whether Heracles performed this deed in the service of King Eurystheus. Up to the time of Diodorus, we read nothing about a contract or squabble with Augeas as mentioned by Pindar, only that the deed was done in the service of Eurystheus. Apollodorus, however, maintains that Eurystheus did not want to accept the deed because Heracles performed it for money.

If all this seems confusing, it ought to. The Augeas adventure differs from the others in many respects; the versions contradict each other and they appear late and seldom. They also have a character of their own which is different from that of the other eleven deeds: Heracles does not have to kill or defeat an odious monster, nor does he have to overcome great danger. Further, it is unique that this deed has to be done in the service of another king—Augeas—and that Heracles can bring no proof to Eurystheus in Mycenae that he has accomplished his task.

Although this deed by its singularity attracts attention, it is nevertheless strange to find it in such an important place as the metopes from Olympia (pl. 1, 12; pl. 29). But this only seems to

be strange. Augeas is the king of this region; Olympia belongs in his kingdom. Local considerations apparently were instrumental in placing this theme within the cycle of the Olympia metopes; the very same reason caused Pindar to mention it in his tenth Olympic Ode. The metope shows, however, that this theme can be depicted in art and that its rare appearance cannot be based upon its ostensible pictorial difficulty.[37]

The position of the fragments of the Augeas metope leads one to assume that it was placed northernmost on the east façade. This metope, therefore, closes the right side of the entire series. Its composer evidently took this fact into consideration. Athena, unmistakable in her helmet, stands in front view and brings the series to a calm conclusion. Only her head and her right arm turn in the direction of Heracles, who, pivoting in the same direction, is full of motion. Ancient writers scarcely mention Athena in connection with this deed, just as with regard to the Stymphalian birds. However, it is obvious that the goddess can always appear if her protegé needs her. What Heracles is doing is less clear. He holds a stick in his hand but we do not know if this stick is part of a shovel or a broom, or if Heracles is using it to push a sluice open.

The appearance of this deed on an Olympia metope did not lead to other monumental pictures of the Augeas adventure. A literary source of the fourth century mentions a statue of Lysippus which, however, has not survived.[38] In this representation Heracles seems to have used a basket instead of the river Alpheus to carry off the dung. From the beginning of Greek art to the beginning of the Roman era we can find no other representations.

On the Roman mosaic from Leiria (pl. 46) Heracles works with a hoe and water simultaneously. Of all the deeds of Heracles, not just the twelve, the Augeas adventure is by far the rarest in Greek art. At the same time it is the latest to be documented.

7. The Cretan Bull

Heracles' seventh task was to bring a live bull back from Crete to King Eurystheus. Here for the first time Heracles leaves the Peloponnese, the place of his first six adventures, if we accept the puzzling version of the Hind adventure recounted by Pindar. Even in Pindar's account, however, the Hind originally came from the Peloponnese and was caught after its escape to another country.

Bull myths have always been popular in Crete. As we know from pictures since Minoan times, bull games and bull fights occupied the ancient imagination: Europa was abducted to Crete by Zeus who appeared as a bull; and Pasiphaë, wife of the Cretan king Minos, fell in love with a bull and gave birth to the bull-man, Minotaur, who was killed by Theseus.

Later mythographers linked the bull that Heracles was supposed to bring from Crete to these legends and naturally to the Marathonian bull killed by Theseus. We can no longer be certain which type Heracles' bull belonged to, for the earliest literary sources, which turn up as late as the fifth century, are fragmentary.[39]

The pictorial representations can be found as early as the mid-sixth century.[40] These are Attic vase paintings which depict the capture, seizure, and fettering of the bull. The theme shows some similarity to the capture and seizure of the boar as interpreted on a pyxis (pl. 17). In view of the many identical representations of the fight with the bull, one black figure amphora in Munich from the end of the sixth century may suffice (pl. 30). In this example Heracles has forced the bull to its knees, fettered its legs and muzzled its mouth; he is about to pull the ropes tight. His costume and quiver hang from a tree; thus we are able to distinguish him from Theseus, who accomplished a similar deed by killing the Marathonian bull. A club lies on the ground; Iolaus carries a second one in his hand. The picture is full of action and agrees with numerous vase paintings displaying a similar interpretation of the bull fight.

There are relatively fewer pictures from the fifth century than from the sixth. One of them, on a calyx krater in Adolphseck (pl. 32), shows an unbearded Heracles who, surrounded by

many divinities, stands in the way of a ferocious approaching bull. The figures are grouped as if on a stage. Despite the rolling eyes of the bull and the posture of Heracles, it is hard to believe in the seriousness of the event. Nevertheless, the legend continued to occupy the later vase painters of the fourth century.

As is the case with Augeas, the Olympia metope is the earliest preserved picture in monumental art. Vase pictures with the full adventure can be traced back to half a century earlier, however.

On the Olympia metope (pl. 1, 4), the interpretation of the bull adventure differs from that on all earlier vases. Neither the chase nor the capture nor the fettering of the animal are depicted, but as in the lion and bird metopes, a later moment has been chosen. The bull is already fettered and is attempting to break free by a few last fierce exertions. The animal rears. His diagonal movement, however, cannot extend to the right upper corner of the metope because Heracles pulls the bull's head downward, toward the center. We do not simply see here two diagonally opposed movements of the bull and Heracles; instead the movements are more artistic and intricate. The head of the bull is turned toward Heracles and the head of the hero toward the bull. Thus the dorsal contour of the bull turns in a sharp angle that continues back to the center of the metope. On the other side, Heracles lifts the club over his head before the bull's tail; his right hand and club lead our eye back to the center of the metope.

The metope master changed the movement of the bull. The archaic scheme of the bull capture would have burst the frame of the metope and the bull's movement to the right would not have yielded a balanced picture. The archaic theme of binding the bull may also have been ill-suited to the metope unless the artist wanted to imitate vase painters who improved their compositions by placing a tree in the empty space above the fallen bull. A maze of small branches and bindings would not have been worthy of a monuumental composition. The master of the Olympia metope looked for an entirely new solution to demonstrate the gravity of this deed. Consequently, Heracles is shown as the victor; thus the artist creates a balanced composition out of the dramatic fight.

Unfortunately, the Olympia metope is the only example of this legend in monumental art for some time. The artist of the Hephaestus temple does not depict the theme, and from the fourth century only one relief of Heracles with the Cretan bull has survived.[41]

8. The Thracian Horses

In his *Alcestis*, performed in 438 B.C., Euripides mentions the legend of the Thracian horses for the first time in Greek literature. Earlier than this only a fragment of Pindar survives.[42] A very short allusion to the legend is found in Hellanicus, which we know from Euripides' record from the post-Archaic period. The author reports that Heracles had been sent to Thrace by Eurystheus to fetch the four-horse team of the Bistonian prince, Diomedes, a son of Ares. In the dialogue between Heracles and the leader of the chorus, both discuss this task (verses 479 ff., see p. 86):

Chorus
But tell us, what is the errand that brings you here to Thessaly and the city of Pherae once again?

Heracles
I have a piece of work to do for Eurystheus of Tiryns.

Chorus
Where does it take you? On what far journey?

Heracles
To Thrace, to take home Diomedes' chariot.

Chorus
How can you? Do you know the man you are to meet?

Heracles
No. I have never been where the Bistones live.

Chorus
You cannot master his horses. Not without a fight.

Heracles
It is my work, and I cannot refuse.

Chorus
You must kill him before you come back; or be killed and stay.

Heracles
If I must fight, it will not be for the first time.

Chorus
What good will it do you if you overpower their master?

Heracles
I will take the horses home to Tiryns and its king.

Chours
It is not easy to put a bridle on their jaws.

Heracles
Easy enough, unless their nostrils are snorting fire.

Chours
Not that, but they have teeth that tear a man apart.

Heracles
Oh no! Mountain beasts, not horses, feed like that.

Chorus
But you can see their mangers. They are caked with blood.[43]

In *Heracles* by the same playwright (verses 380 ff., see p. 87) we are told that the hero tamed the man-eating horses of Diomedes and that he rode with them in a four-horse chariot from the silvery waters of the Ebros (in Spain) to Mycenae. In both cases we have a four-horse chariot. The fate of the original owner, Diomedes, is not mentioned, but the *Alcestis* indicates that he might have been killed by the hero.

According to Diodorus, Heracles tamed the man-eating horses of the Thracian, Diomedes, by feeding them their own lord; afterwards Heracles brought them to Eurystheus, who dedicated them to Hera. Supposedly, the offspring of these horses were still living at the time of Alexander the Great.

Apollodorus described the Thracian horses as man-eaters. In his story, Heracles kills the Bistonian prince during a fight and then takes an unspecified number of horses to Eurystheus in Mycenae.

Pictorial representations preceded the literary sources. The artist of a black figure Attic lekythos belonging to the Archaic period (pl. 28) depicts Heracles seizing four winged horses. He seizes one of them from behind by chasing the horse and grasping him at the neck in the manner vase painters prefer

when depicting the capture of the bull. The picture tells as little about Diomedes' fate as does Diodorus' text.

Unfortunately, pictorial representations of this deed are rare, almost as rare as those of the Augeas adventure.[44] But the Archaic representations of the horse adventure are not restricted to vases. We must mention a metope in very bad condition from the Athenian treasury in Delphi.[45] The composition cannot be easily reconstructed. A lost Archaic relief which Pausanias saw in Sparta on the Amyclaean throne provides us with little additional information. From his description (3.18.7) we gather that Heracles was depicted punishing Diomedes.

On the metope in Olympia[46] (pl. 1, 8) Heracles is shown without Diomedes and with only one horse. Here, as in the case of the Archaic relief, we have no reason to doubt Pausanias' interpretation. As on all the Olympia metopes secondary figures have been omitted. In most of the other deeds we see Heracles with a single opponent. The artist who gave us this interpretation of the Thracian horses thus had to ignore subsidiary figures such as Iolaus in order to concentrate on the essentials. The logic of the composition could not allow the representation of either Diomedes or a multitude of horses. An identical solution was used for the Hephaisteion (pl. 2, 5). The motif is related to that of the bull metope.

In pre-Hellenistic monumental art this theme was used on a relief from near Sunium.[47] It also depicted a single horse.

9. The Amazons

The Amazons lived in the far east or northeast, in Asia Minor, either near the Scythians or near the Caucasus mountains, or perhaps in an Eastern country about which the Greeks lacked precise geographic knowledge. Legendary stories circulated about the Amazons or some strange race. Probably these people had a form of matriarchic society which seemed to the Greeks barbaric and alien. The result was that this race fired the Greek imagination. The Greeks may have expressed their knowledge about these people in their legends. Perhaps the numerous representations of combats between the Greeks and Amazons reflected the Greek wars with the Persians. Even as late as Classical times an Amazon was considered the essence of barbarism.

Not only Achilles, Bellerophon and Theseus but also Heracles are linked to fights with Amazons. In the first half of the fifth century Pindar tells us (frag. 172 [158]) that Heracles and Peleus set out to fetch the belt of the Amazons. The title of a contemporary comedy of Epicharmus confirms that both men sought the belt. Euripides also mentions this episode in his *Heracles* (5, 407 ff., see p. 88). The belt was stored at Mycenae. Apollonius Rhodius, Plautus, Diodorus, and Apollodorus made it Heracles' task to capture the belt of the Amazon, Hippolyte.[48] Diodorus has Heracles kill many Amazons in a fight, but he is silent about a combat with Hippolyte. Apollonius Rhodius reports the peaceful seizure of this belt. According to Apollodorus, however, Heracles killed Hippolyte. The seizure of the belt is always Heracles' objective; on this point the literary sources are in accordance for many centuries.

Again the pictures make it possible to trace this legend back to earlier periods. The Amazon adventure is second only to the lion combat in popularity in Greek art. A clay votive shield from Tiryns made in the beginning of the seventh century depicts a fight between warriors and Amazons. If the main group is not Achilles and Penthesilea, then it may represent the combat between Heracles and the queen of the Amazons (pl. 33).[49] At this time the later picture typology of Heracles had not yet been developed. On the other hand, this would not be

the only Heracles deed found at such an early date.

The interpretation of a Corinthian vessel made in the seventh century (fig. 8), however, is certain. Heracles appears without his typical attributes—for example, the lion skin. This type is also found on the shield from Tiryns, but the inscription on the Corinthian vessel clearly identifies Heracles. The leader of the Amazons, though, is not Hippolyte, as indicated in literature, but Andromeda. The object of the fight, the belt, cannot be seen.

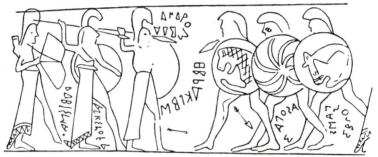

Fig. 8. Corinthian Alabastron. *Heracles and the Amazons*

From an early date Attic vases abound with the theme of Heracles fighting the Amazons; it has survived in several pictures from the first half of the sixth century, a period for which we have scant Attic pictures of the twelve deeds. Here, as well as on later black figure pictures, we see a fight in which the opponent of Heracles is defeated, even though some of the other Amazons may overwhelm one of the hero's companions. In most cases Heracles fights with a sword. The fight is often a bloody one, and the goal seems always to be the killing of an Amazon. None of the more than one hundred Attic black figure vase pictures depicting this theme hints at the seizure of the belt. Apparently this motif emerged at a time when the belt of the female costume played a more important role than it did in the sixth century.

As early as the second quarter of the sixth century Heracles is characterized by his lion skin, even though it does not always appear worn on his head but is sometimes knotted in front of his chest. The helmet he wore on the earliest pictures of the Geometric period and of the seventh century has by now

disappeared (pl. 34). On other vase paintings of approximately the same time an inscription identifies Andromache as his enemy.[50] Half a century later, on a red figure cup, the enemy is still Andromache (pl. 35). Here one of the Amazons uses a bow in a manner that recalls a Corinthian vessel (fig. 8); otherwise the Amazon wears a barbarian costume, something uncharacteristic of early Attic representations of Amazons where the women were not characterized as aliens.

Red figure vase pictures of the Amazon fight are fewer than black figure representations. In most cases they belong to the last quarter of the sixth century (for instance, pl. 35); the remaining ones date to the period of the Olympia metopes. From the second half of the fifth century continuing on into the fourth century not one Attic vase depicts the fight against the Amazons. On red figure vases Heracles also defeats the Amazons. The combat is always a life or death struggle and never is its goal simply the seizure of a belt. One Campanian vase picture of the fourth century, however, shows an Amazon standing in front of a horse freely surrendering her belt.[51]

Monumental art of the sixth century in Olympia used this theme.[52] Unfortunately the Olympia group is lost. Pausanias, who saw it in the second century A.D., describes it as "... Heracles fighting for a belt with an Amazon on horseback..." (5.25.11). We can no longer learn whether the belt itself was depicted in this group. In all likelihood this is a work by Aristocles and is similar to other Archaic representations which depict a simple battle group. Pausanias may have ascribed the seizure of the belt to this group, from a story known to him. This sculptural group evidently does not correspond to the typology of Attic vase pictures, which after the late sixth century show Amazons on horseback. Generally the opponent of Heracles fights on foot. The metope of the Athenian treasury in Delphi is too fragmentary to discuss here.

Pausanias describes the metope from the Zeus temple in Olympia as if Heracles were fighting for the belt of his rival Amazon. The bad condition of the metope does not permit us to corroborate Pausanias' account (pl. 1, 6). We know for certain that unlike Archaic pictures and the metope of

Selinus[3] this work did not show the fight itself. As on most metopes at Olympia, a moment has been chosen which leaves less doubt about the outcome of the combat than that in earlier pictures. The artist of the third Amazon metope of the fifth century, that from the Hephaestus temple (pl. 2, 7), seems also to have chosen a later phase of the fight.

A shield band relief from Perachora may have depicted the same theme.[54]

Generally the pictures represent a version of the legend we do not know from ancient authors. Neither the name of Hippolyte nor the seizure of the belt appear in the representations. It may therefore be that in the early period, when we have only images and no literature, the belt motif was not yet known; it may have been ascribed to pictures showing the fight at a later time (or, as in the case of the Campanian vase, simply adopted). Possibly, too, the pictorial tradition was always independent from a literary one, as may have been the case with the legends of the Hind and the birds.

10. Geryon

Geryon, a three-bodied male, lived in the far west, i.e., on the island of Erytheia beyond the Oceanus River. He owned herds of cattle guarded by the shepherd, Eurytion, and his dog, Orthus. Heracles' task was to steal the cattle and bring them to Eurystheus. For this purpose he had to defeat Geryon, Eurytion, and Orthus.

This legend is one of the few which can be found at an early period in both literature and pictures. Its core, moreover, continued to remain the same in both and to follow the same tradition.

Hesiod in his *Theogony* (verses 287 ff., 981 ff.) mentions the legend. Stesichorus, the poet of the sixth century, wrote an entire book on Geryon, called *Geryoneis*. During the fifth century the story is mentioned in a fragment of Pindar, in the *Herakles* of Euripides (verses 422 ff., see p. 88) and by other authors,[55] particularly those of later centuries. The literary tradition is rich and, as far as we can perceive, also uniform.

Pictorial tradition also begins in the seventh century. The earliest picture can be found on a proto-Corinthian pyxis (pl. 37). Despite its small size and rather careless drawing, Heracles with his quiver, arrow, and bow is unmistakable, as is his three-bodied opponent. Shepherd and dog are omitted but not the herd, which occupies the entire back of the vessel. Heracles, as observed on some pictures of the Hydra fight, shoots his bow from a distance and continues to fight with sword or club at close quarters. The three bodies of Geryon are clearly visible. Already on this earliest picture Geryon is conceived of as an armed warrior, as his three shields demonstrate. On a later bronze shield band, the hoplite armor of Geryon is complete, as it is on all later monuments.[56]

A peculiarity makes the two known Chalcidian vases[57] showing Geryon particularly important. They depict him with wings. No other picture adopts this version, which is evidently the way that Stesichorus described him.

The Attic black figure vase pictures with Geryon are numerous.[58] From the second half of the sixth century we know sixty-eight, and they vary little. The combat scheme is almost

always identical: Heracles attacks Geryon from the left, and one body of Geryon is hit. Between both opponents we normally see Eurytion or the dog downed by an arrow. A typical picture appears on a Munich amphora (pl. 31).

Red figure pictures with Geryon, however, are rare. As with the main body of black figure vases, they too belong to the last third of the sixth century. On the other hand, no Attic red figure representation from the fifth or fourth century has survived. The exterior of the cup decorated by Euphronius is all the more significant (pl. 38). Both sides form one compositional unit. The battle scheme of the main side is remarkably similar to the earlier pictures. With one hand Heracles holds the bow with which he has shot one of Geryon's heads, the dog and the herder. The dog has two heads and a snake tail similar to his brother dog, Cerberus. The fallen Eurytion has been removed from the middle of the scene to a position under the handle of the cup, thus adroitly taking advantage of the form and limits of this vessel. Iolaus, Athena, and a woman enhance this picture. The inscription which names the participants adheres precisely to ancient accounts. On the other side of the cup we find the herd of Geryon and other companions of Heracles armed in the same style as Iolaus.

As early as the sixth century this theme appears in monumental art. Thanks to the descriptions of Pausanias, we know of the pictures on the Cypselus chest (5.19.1) and on the Amyclaean throne (3.18.7). But above all this theme was a favorite for metopes. On the Athenian treasury in Delphi the Geryon, together with the lion and Hind themes (pl. 7), fills six metopes on the west side (the direction of Geryon's home).[59] Heracles and the dead dog appear in one, the armed Geryon in a second (pl. 20). In keeping with the vase representations one of his bodies is hanging to the ground. Three other metopes, in less well preserved state, show the herd, and the sixth metope shows the chariot used by Heracles on his way to Geryon. It is striking that six metopes are devoted to this adventure, since other popular deeds of the hero have been omitted on the Athenian treasury. The Geryon legend, therefore, must have been very popular at that time. Indeed, Stesichorus' book is literary proof of this popularity.

The metope from Olympia contrasts sharply in narrative style to the metopes of the treasury in Delphi. The theme is represented in one metope. Athena, Iolaus, the herd, Eurytion, and the dog are all missing (pl. 1, 9). As on earlier vases, Heracles has almost defeated Geryon. All three bodies, not just one, have been hit. Here, as well as on the other Olympia metopes, the fight has reached a decisive stage. As in the Hydra adventure (pl. 1, 2), the fight is still in progress but the outcome is clear.

As with the Diomedes adventure, killing the opponent was not the goal; it was the means to an end. In the former instance Heracles had to capture horses; thus it makes sense to depict Heracles with a horse (pls. 1, 8; 2, 5). In the latter he must capture cattle, but in this case he cannot be depicted with one of them, for doing so would have led to confusion with the Cretan bull metope (pl. 1, 4). Thus the artist had to depict the fight with Geryon. In the lion metope (pl. 1, 1; pl. 9) it made sense to depict the dead animal, for with killing, the deed was terminated. The same is true for the Stymphalian birds (pl. 1, 3). But Heracles standing above the defeated Geryon would have been only one aspect of the myth, perhaps not even a very important one. Owing to the peculiarity of this theme, the fight itself had to be depicted. There is no doubt, however, about its outcome, and its inevitability identifies this metope with all others from Olympia.

In contrast to the new, personal interpretation of this legend, the artist of the Hephaestus temple borrowed from earlier concepts. On ten eastern metopes only nine adventures of Heracles are shown, for the Geryon exploit occupies two metopes (pl. 2, 8–9). Half a century had passed after the narrative vitality of the Archaic period as noted in our discussion of the metopes of the Athenian treasury. We can offer no reason for the distribution of Geryon over two metopes other than the artist's inability to depict the myth within one; and this explanation seems inadequate, for the cattle and dog have been omitted. Moreover, Geryon is interpreted more conventionally here than on the Olympia metope: one of his bodies still stands and fights. The outcome is clear, as on the Olympia metope.

The Geryon fight covers at least two panels on a fourth-century relief from Sunium.[60] Its breadth and elaboration distinguish it from the representations on the treasury and the Hephaestus temple, as well as the representations on later monuments. The theme is known on vase paintings in the same century—for example, on the Apulian vessel depicting Geryon lying defeated on the ground.[61] Within the time period discussed here, the basic idea of the myth did not change.[62]

Only a few Attic vases depict the episode where Heracles threatens Helios and the hero subsequently rides over the Oceanus river in the cup of the sun god.[63]

11. Cerberus

According to Hesiod's *Theogony* (310), Cerberus, the underworld dog, was a particularly horrifying being. A brother of the Hydra and of the dog Orthus, well known from the adventure of Geryon, Cerberus has generally been described as two-headed, although sometimes he has more heads. Heracles has to seize and present Cerberus to Eurystheus.

This deed is the only one of the famous twelve which turns up earlier in literature than in pictures.

In the *Iliad* (8.364 ff.) Athena tells how she guided Heracles when he had to seize the dog of the underworld for Eurystheus. The *Odyssey* also mentions the dog of Hades but without giving his name or more detailed description (11. 621ff.). In the latter work, Athena and Hermes join in the seizure of the dog.

The *Theogony* describes the dog as horrific but does not mention Heracles in connection with the animal. Hesiod gives it fifty heads. Just as writers could vary the number of heads of his sister, the Hydra, so their fantasy is unrestricted in assigning heads to Cerberus. By comparison, the pictorial artist's imagination is not given such free rein.

Stesichorus and Pindar (frag. 79) deal with the Cerberus theme in poems, and Sophocles in a Satyr play. All these works survive only in title. In the *Trachiniae* of Sophocles (5. 1098, see p. 86)[64], Cerberus has three heads, in agreement with Hesiod who describes him as a son of Echidna; in the *Heracles* of Euripides (5. 20 ff.) he has three heads and possibly three bodies as well. Euripides is the first to tell us that Heracles succeeded in capturing Cerberus in a fight and that Cerberus did not stay with Eurystheus but returned to the underworld. Diodorus apparently did not conceive of this capture as such a forceful, violent act. According to his report, Heracles had himself initiated into the Orphic mysteries because Orpheus knew how to bring animals under his spell; then, assisted by Persephone, Heracles accomplished this deed.

In the work of Apollodorus, as well as in that of Euripides, the Cerberus adventure is the last of the twelve canonical deeds. Here Cerberus has three heads and a snake for a tail as

well as other snakes on his back. When Heracles demands Cerberus from Pluto, the latter orders Heracles to capture the dog without weapons. Heracles accomplishes that task by throttling the dog. In doing so, however, he is bitten by Cerberus' tail-snake. Heracles shows Eurystheus the dog and returns him to Hades.

The literary tradition differs from the pictorial in the more or less fantastic description of Cerberus.[65] The basic features of the legend, however, remain the same over the course of centuries. No statement in the early literature contradicts Apollodorus in reporting that Cerberus was defeated without weapons. Whether all of the authors depict this conquest as a strangulation, as Apollodorus does, is unclear. Homer's account mentions Athena's assistance but Diodorus is silent on this point. On this detail the ancient literature is not in agreement.

For these reasons it is interesting to examine the pictorial evidence on this question. The earliest representation comes from a Corinthian vessel made in the early sixth century. The vessel is now lost, but we have a drawing of it, and it has been mentioned before because it also shows the Hydra fight (pl. 36). Heracles accompanied by Hermes enters the sphere of the underworld. Heracles is armed with a bow which seems to have no purpose other than to identify the hero, for he does not use it. He exhibits great fear: Hades flees, and Cerberus—one-headed, with several snake bodies—hurries in the opposite direction and looks back in fright. The source of Heracles' magical power evidently comes from the object he holds in his raised left hand. Is it a stone or some magic potion? Whatever interpretation we choose presents a version of the legend not found in ancient literature or in other representations.

Two Caeretan hydriae display the Cerberus adventure. The artists chose another aspect of the story; the presentation of the underworld dog to Eurystheus.[66] Heracles has the dog, which appears with three heads and numerous snakes on his front, on a leash. The monster jumps at Eurystheus who, out of fear, jumps into a pithos. This incident matches the similar one in the story of the boar. No doubt the painters of these two hydriae borrowed this motif from the other adventure. In no other representation of the Cerberus deed do we see Eurys-

theus; always we see Heracles either in the underworld or on his way to his employer. The key episode in connection with the Erymanthian boar can be found two decades prior to these Caeretan hydriae. Their maker must have adopted it in order to create a more original picture.

The Attic Cerberus pictures usually date from the last quarter of the sixth century. Few were made before this time and still fewer after. Cerberus almost always has two heads. A fight similar to the one with the lion and compatible with Apollodorus' description never occurs. The artists prefer scenes that show Heracles calming Cerberus in Hades[67] or negotiating with Hades or Persephone, who is sitting in her palace. In the picture Hermes takes the lead and, since the dog crouches fearfully under his outstretched arms, we perceive Hermes' intention not only to stroke the dog but also to entrance him with magic. This interpretation is close to that of the Corinthian vase picture (pl. 36) made about seventy-five years earlier.

Some vases describe the transport of Cerberus to Eurystheus; none show the arrival in Mycenae. Either Heracles has Cerberus on a leash and forces him on with his club (pl. 41) or he drags the animal along (pl. 40). Cerberus obeys without strong resistance. Even if Hermes is absent, Heracles never needs to use force as he did with the boar.

No post-Archaic Attic vase painting has survived, but the vase paintings of south Italy use the Cerberus theme often in the course of the fourth century.

Pausanias mentions that he saw this theme on the Amyclaean throne (3.18.13). The earliest preserved works in monumental art were created about one century after the first Cerberus vase pictures. Apart from a very fragmentary monument on the Acropolis,[68] there is a relief on the base of a monument which may have represented Heracles;[69] at least all other sides of the base display other adventures of Heracles. The composition, well suited to the low area, shows some parallels to the scheme of the horizontal lion combat, one very popular at that time and repeated on another side of this base. Heracles drags the resisting dog forcibly out of a corner where Cerberus tries to conceal himself. This rather decorative work shows little artistic mastery.

Pausanias forgot to describe the Cerberus metope in Olympia (pl. 1, 11). The motif is similar to the bas relief mentioned above, but the composition is improved. The tensions of the interdependent forces unfold freely over the whole area. They are, nevertheless, effortlessly framed by the square of the metope and remain seemingly unhindered by the frame. which in the case of the bas relief gives the composition its determining character.

In composition and content the metope of the Hephaestus temple borrows heavily from the Olympia metope (pl. 2, 6). It survives as the last representation of the Cerberus adventure in monumental art prior to the Hellenistic period.

12. The Apples of the Hesperides

According to legend, the golden apples of the Hesperides are guarded by a terrible snake, an offspring of Ceto and Phorcys. There, at the end of the world, near the musical Hesperids, stands Atlas carrying the heavens on his head and hands. This is a concept that Hesiod develops in the *Theogony* (verses 333 ff.; 517 ff.), and it reappears in the play *Hippolytus* (verse 741) of Euripides. Although both writers mention Heracles confronting Atlas, they are silent about the adventure of the apples.

The literature of the fifth century first brings together the apples and the scene at the end of the world. Sophocles in the *Trachiniae* (5.1099 ff., p. 86) describes the hero's arrival at the lair of the snake which lived at the outermost edge of the world guarding the apples. It seems that Heracles himself overcomes the snake. In his *Heracles* (394 ff., see p. 87) Euripides states specifically that Heracles killed the snake and picked the fruit. Pherecydes,[70] on the other hand, has another version: Heracles orders Atlas to pick the apples for him while he himself carries the heavens. Atlas wants to show the apples to Eurystheus, but to hinder Atlas in this endeavor Heracles employs a ruse and asks Atlas to take the heavens on his shoulders once more until he can place a pillow on his own. Atlas accepts, puts the apples down, and takes up the world again. As he does so, Heracles siezes the apples, bids farewell to Atlas and leaves for Mycenae.

Thus we see that the literature of the fifth century tells two different versions of the legend, whose antecedents we are unable to trace. Oddly enough Euripides combines both stories for, immediately after killing the snake, Heracles sets out to visit Atlas.

Possibly these versions are not mutually exclusive but only seem so today because of their fragmentary state; otherwise the text of Euripides would not make sense. In Diodorus' story Heracles accomplishes the deed himself. In turn Apollodorus borrows from Pherecydes. The literary sources contradict each other, especially in the matter of the geographic location. Did these events occur in the Peloponnese, the farthest north, the west, or Cyrene?

No literary evidence from the Archaic period can be found for this labor.

Strangely enough, pictorial evidence does not clarify these contradictions. Archaic vase pictures, apart from the Attic, have not survived. The Attic vase paintings begin just before the last quarter of the sixth century and are quite scarce.[71]

On pictures which appear a few decades before the literary sources, we can see the same tendencies as in literature. Heracles momentarily assumes the burden of the starry sky, while Atlas is bringing the apples (pl. 42); the hero himself has made his way almost to the tree guarded by the snake in order to pick the apples (pl. 43).

Red figure representations of the fifth century are very rare. Sometimes they represent the garden of the Hesperides but do not show the hero inside. One composition (fig. 9) shows the fight with the snake,[72] but the fighter is not Heracles—it is a Silene who must have stolen the hero's club and placed a lion skin around himself. The tree does not display the golden apples of the Hesperides but crude wine jugs, an understandable goal for a Silene. No doubt this is a scene from a Satyr play in the course of which a Silene adopts Heracles' role.

Representations of Heracles himself in the garden of the Hesperides are very rare. Those of Atlas on Attic red figure vessels of the fifth century are entirely unknown.

One of the most beautiful images appears on an alabastron in Nauplia (pl. 44).[73] The entire picture field of this Classical ointment vessel is covered with a fine white ground. The apple tree is in the center, and the snake coils around it. To the left stands a Hesperid with two apples in her right hand, while with her left hand she is about to pick a third. At the right Heracles sits conspicuously on a rock. Earlier representations in the Archaic period depict Heracles fiercely fighting the evil snake or sighing under the burden of heaven, and give the job of apple picking to Atlas. In the imagination of the people of that period, this deed involved dangers and hardships. On the alabastron, however, the snake has lost much of its former frightfulness (just as the Hydra on the vessels of the fourth century has lost its terrifying aspect, as seen in plate 14). Moreover, the artist of the alabastron did not attempt to show

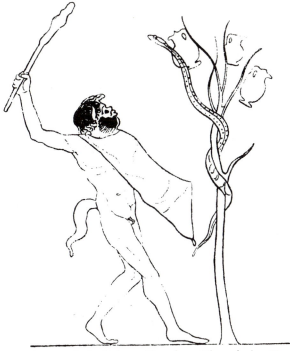

Fig. 9. Attic Red Figure Oinochoe. *Silene playing Heracles*

Heracles' great suffering. The Hesperid picks an apple for him, and Heracles, ignorant of the snake, is waiting to receive it. Here a Classical type is substituted; it lacks the energy and animated action of the Archaic picture and instead concentrates on mood. The hero puts no effort at all into the deed; someone else performs it for him. He does not have to offer anything in return, as with Atlas. He emerges unscathed from his services to Eurystheus. He receives gifts befitting a hero.

All this recalls the way the Olympia master reinterpreted the role of Heracles on the lion metope (pl. 1, 1; 7). There, as we mentioned before, the hero is shown after the combat. We are given a view of Heracles' mood, created by the traces the combat has left on him.

During the fifth century the Meidias painter also treated the theme.[74]

Although the Hesperides adventure enjoyed great popularity during the fourth century, other adventures of Heracles be-

came less frequent and their representations on Attic vases decreased or stopped entirely. On no Attic vase of the fourth century, however, do we see Heracles involved in a fight. Rather he is standing or sitting. He is always the victorious hero (pl. 45), the admired center of the picture. The Hesperides are his helpers; the snake is no longer a match for him. Fourth-century pictures reveal a general state of blissfulness and serenity.

As early as in Archaic times, Cyrene, the home of the Hesperides, minted a coin with the Hesperides motif.[75] Several Attic vessels of the fourth century depicting the same theme have been excavated here. Attic pottery workshops took local wishes of their export customers into consideration. Italic potters found the Hesperides theme attractive and both versions of the legend were known to them: the version in which Heracles himself picks the apples and the version in which Atlas does it for him.

Remarkably enough, monumental art leads us further back than the vase pictures.[76] Unfortunately the earliest examples have not survived. But Pausanias describes three large monuments of the sixth century, all of which were in all likelihood made prior to the earliest known vase pictures. There is no question that the earliest vase pictures must have existed at that time. Thus we see how accident has preserved only certain monuments for us.

Pausanias (5.17.2; 6.19.8; 6.19.12) describes a group in Olympia which, according to the inscription, was made by Theocles and his father Hegylos. At the time of Pausanias this group was shared or distributed between the treasury of the Epidamnians and the Heraion. It was made of cypress wood and consisted of five Hesperides, Atlas, Heracles, and the apple tree with the snake. From this description we gather that Theocles, like Euripides, attempted to combine both versions of the legend in this large group.

Pausanias (5.18.4) also describes the Cypselus chest in Olympia; Heracles attacks Atlas, who is shouldering heaven and holding the apples in his hand. This version of the legend has no parallel in literature or art.

Unfortunately Pausanias (3.18.10) is quite laconic in describing the representation of Atlas on the Amyclaean throne.

The earliest preserved work of monumental art is the metope in Olympia (pl. 1) where in the center of the panel Heracles is carrying the heavens on a cushion. Athena assists him. Atlas approaches them with three apples in order to give them to Heracles. Here again the artist selected a moment close to the end of the adventure. We are told nothing about the fight with the snake or a quarrel with Atlas. Thanks to the help of Athena the hero is not bent over, as on Archaic vase pictures, yet neither does he rest in the relaxed manner of Classical pictures. He knows what he is doing. The composition is articulated by three verticals, but monotony has been avoided because the artist has depicted one figure from the front, the second from the side, and the third from a three-quarter view. The free space between Heracles and Atlas emphasizes the three apples which link the two figures together. Athena herself brings

Fig. 10. Reconstruction of Three Figure Relief.
Heracles and the Hesperides

about the link with Heracles; she looks in the direction of the hero and helps him to carry the burden of the heavens. Pausanias describes the scene as if Atlas was supporting the world, but there is no question that Heracles is the central figure. According to his account, we get a similar impression from the

painting of Panaenus on the parapet of Zeus's throne in the same temple. This piece matches a second statue with two Hesperides. Through ancient literature and modern excavations we know Olympia better than many other places; we also know it through Pausanias' descriptions and from as many as four Archaic and Classical works of monumental art apart from the preserved metopes.

At least one metope of the Hephaestus temple (pl. 2, 10) represents the Hesperides adventure.[77] Here the apples are already in Heracles' hands.

A relief, the original of which has unfortunately been lost, was made about half a century after the Olympia metopes. Only fragmentary copies have survived. Here we can complete the composition with a drawing (fig. 10).[78] As on the Olympia metope the composition consists of three figures linked less by their action than by their inner mood. The hero is seated, a position introduced for the first time on the alabastron. No other picture shows him seated. The Hesperides have done the deed for him and are bringing the apples. The snake is missing altogether. No longer the strong warrior, no longer the enduring hero, Heracles takes on the air of one blessed.

IV

The Cycle of The Twelve Labors

The twelve adventures treated here first appear on the metopes of Olympia (pl. 1). These metopes depict precisely the twelve canonic deeds.

We encounter the identical adventures, however, on later monuments also.[79] A typical example is a mosaic from Spain (pl. 46) made about seven hundred years after the Olympia metopes.[80] It is particularly instructive because all twelve panels surrounding the central picture have been preserved and because there can be no doubt that this mosaic, even though in an entirely different medium, of a different date, and from a different region, depicts exactly the same series as the Olympia metopes. Such similarities cannot be accidental. In fact, other examples of ancient literature and art confirm this congruence.[81]

Therefore, there can be no doubt that the cycle called the Dodekathlos did in fact exist. The question, however, is when the cycle became canonical.[82] Many suggestions have been made to explain the date of the creation or origin of the Dodekathlos. The periods suggested range from the early art of the orient, to the Mycenaean period, through the eighth century B.C., to even later periods. The Archaic period is most often proposed.

The above discussion has shown that the earliest evidence for different legends comes from different periods. Art of the eighth century had already illustrated the adventures with the lion, Hydra, Hind, and the birds; the literature of the same period knew only the adventure of Cerberus. The Amazon and Geryon deeds are first seen during the seventh century. On the other hand, the adventures with the boar, bull, horses, and Hesperides cannot be found before the mid-sixth century or perhaps even later, and the Augeas deed does not appear until

the fifth century. A chart may help to illustrate the earliest appearances in art (o) and literature (x) according to present scholarship. This chart suggests that pictorial representations were important for the history of the legends because they existed before the literary sources. Owing to new finds, this chart may, of course, become outdated. We cannot be certain that myths were represented the moment they were created, nor can we expect to know with absolute certainty the first representation of any myth.

LABOR	8th cent.	7th cent.	6th cent.	5th cent.	TEXTS
1. Nemean Lion	o	x			Hesiod, *Theog.* 332 Bacchylides 9.4
2. Lernian Hydra	o	x			Hesiod, *Theog.* 313
3. Erymanthian Boar			o	x	Hecataeus, fr. 344; Sophocles, *Trach.* 1097
4. Ceryneian Hind	o			x	Pindar, *Ol.* 3. 29 (Pisander)
5. Stymphalian Birds	o	x			Pisander; Hellanicus, fr. 61; Pherecydes, fr. 32
6. Stables of Augeas			o x		Pindar, *Ol.* 10
7. Cretan Bull			o x		Acusilaus, fr. 26
8. Thracian Horses			o	x	Euripides, *Alcestis* 483
9. Amazons	o		x		Pindar; Epicharmus
10. Geryon		x o			Hesiod, *Theog.* 287 ff., 981 ff.
11. Cerberus	x	o			Homer, *Iliad* - 364 ff.
12. Hesperides			o x		Panyassis, Euripides; Sophocles

Nonetheless, the number of monuments preserved may indicate the popularity of individual legends at various times. Therefore, it is improbable that a legend illustrated quite late and rarely shown would have been depicted as early as the Geometric period. The Augeas deed, which appeared late and was rarely portrayed, is an example. If our idea is in fact true, then the Dodekathlos could not have existed during that early

period, at least not in the form of the Olympia metopes. For example, Homer mentions Heracles and his service with Eurystheus but does not tell us that Heracles finished twelve deeds, much less the canonical twelve. The Homeric hymn to Heracles mentions "many" deeds in the service of Eurystheus, but not the twelve.

In art, it seems highly unlikely that a Dodekathlos could have been created during the Archaic period, for Archaic art almost never shows cyclical combinations. The large pediment at Corfu, for example, unites elements which do not in our eyes have a noticeable correlation, although they appear in one picture. On the shield bands of the Archaic period, where individual panels were decorated with mythological scenes, at least ten Heracles legends can be identified, but only four of them belong to the canonic deeds: lion, Hydra, board, and Geryon. One panel may perhaps represent Heracles fighting the Amazons. These representations of shield bands, however, are never presented in cyclical arrangement; rather one picture of Heracles alternates with one of the Trojan cycle or perhaps one of Theseus (pl. 16). A guiding principle for the arrangement cannot be found. The same holds true for other works— vase pictures, temple metopes, etc. On some monuments, we see one deed—a centaur fight—extended over several metopes; this treatment seems to anticipate later depiction of a cycle of deeds. Even though in such arrangements several Heracles deeds are shown, we always find next to a canonic deed deeds which do not belong to the Dodekathlos.

Pausanias, for example, describes two such monuments of the sixth century; one is the chest of Cypselus. From among approximately three dozen scenes, five of which depict Heracles, only three belong to the canonic twelve. This chest is similar to the Amyclaean throne where, from among forty scenes, Heracles appears fifteen times, but only six scenes come from the cycle. Pausanias (3.17.3) mentions many canonical and other deeds of Heracles on the Athena Chalkioikos in Sparta; unfortunately, he does not tell us how many or which deeds. At Foce del Sele, Heracles is represented on at least fourteen of the thirty-six metopes; among them, however, are only two canonical deeds, the lion and the boar.

The arrangement of deeds in the Archaic period was determined simply by their popularity. The popularity of several adventures changed as time passed. A Dodekathlos from 600 B.C.—provided such a thing existed—would have consisted of entirely different deeds from a Dodekathlos of one hundred years later.

About 500 B.C., towards the end of the Archaic period, we find for the first time the beginning of what we would call a cycle; one half of the thirty metopes of the Athenian treasury in Delphi was apparently reserved for Theseus and the other half for Heracles. It is remarkable that from this time forward various deeds of Theseus emerge in art and that they are immediately arranged in series in metopes and in cyclical form in vase paintings. Towards the end of the sixth century in vase pictures about six of Theseus' deeds were arranged in close juxtaposition. Such was not the case with deeds of Heracles in Attic vase painting—the possibility of finding a cycle for twelve deeds is even less likely.[83] The vase painters of Archaic and Classical times sometimes painted a Heracles deed on one side of a vase and another deed on the other side. This did not occur as often as one might expect. We certainly do not have Heracles cycles on Attic vase pictures of the Archaic and Classical periods.

The case is different with Theseus' deeds; the reasons lie in the fact that several deeds of Theseus remarkably resemble several of Heracles. They may have been introduced at the same time for political reasons. Thus, they are frequently found together.

It may, therefore, be no accident if the cycle of Heracles deeds on the Athenian treasury appears there with the Theseus cycle. Here as well as on the Hephaestus temple in Athens the attempt to create a Theseus cycle has influenced the representation of Heracles' deeds in cyclical form.[84] But even in Delphi there is no Dodekathlos, although there were more than twelve metopes at the artist's disposal. The Geryon adventure has been distributed over the six western metopes (pl. 20). The nine on the long north side display the adventures of the lion, Hind (pl. 7), the centaur and Cycnus. Already from among the five identifiable deeds there are two which do not belong to the Dodekathlos. It makes sense, however, that the Cycnus theme

was chosen for a metope on this Delphic building because according to legend Cycnus lived near Delphi. The state of preservation of the remaining six metopes is worse. We can with some certainty identify Atlas, horses, and Amazons—i.e., the canonical deeds. The theme of one of the three remaining metopes seems to have been the fight between Heracles and Apollo over the Delphic tripod,[85] a theme of extraordinary popularity in Archaic times and one most appropriate for Delphi. This theme was represented on a metope on the building at Foce del Sele; in addition it appears on a pediment of the Siphnian treasury at Delphi. These two buildings were constructed before the Athenian treasury. Could this badly destroyed metope depict the fight over the tripod? Perhaps. Some scholars doubt whether this metope belongs to the Athenian treasury.

More recent studies have pointed out that two other Heracles deeds are missing on the Athenian treasury. Perhaps these two missing deeds belong to the canonical dozen. If so, the treasury in Delphi with its fifteen Heracles metopes could have displayed at most eight canonical deeds. Since it appears on the Olympia metopes (pl. 1), we might assume the cycle was formed before its incorporation in the temple at Olympia. We also might assume that the cycle was fully established after Olympia; even the theme of the east pediment has no forerunner in art. In fact we cannot assume so.[86] From the very beginning of the depiction of Heracles adventures in the eighth century B.C., for almost half a millenium of Greek history down to the Hellenistic period, the only positively identified instances of the Dodekathlos in art and literature are the Olympia metopes.[87] Since Eurystheus appears in this cycle only in the boar adventure the artist may not have known about the fact that some of these deeds were connected with Eurystheus. The Stymphalian birds were handed to Athena instead of to the king. Euripides, however, in *Heracles* (579), counts the lion and Hydra adventures among the Eurystheus deeds.

On the Hephaisteion in Athens not all eighteen metopes are reserved for Heracles or Theseus alone (pl. 2); ten of these were assigned to Heracles, eight to Theseus. Obviously, the artist could not depict a Dodekathlos here. Only nine of Heracles'

deeds are visible because the Geryon adventure is distributed over two metopes. These nine come from the twelve canonic deeds. From among the nine representations by Panaenus in the Zeus temple at Olympia, four were reserved for Heracles. One is non-canonic; the second deed is distributed over two slabs; thus in the nine scenes only two canonic deeds appear.

Apparently there were twelve metopes on the fourth century Heracles temple in Thebes; in his description Pausanias does not mention the birds or the Augeas deed. Thus, we have evidence for the existence of no more than ten canonic deeds.

Strabo tells us that some deeds were depicted by Lysippos for the city of Alyzis in Acarnania,[88] Lysippus' works were later brought to Rome. Unfortunately Strabo fails to mention how many works were brought. There is a fourth century relief from the area of Sunium, extending over several panels—perhaps there were originally twenty-four.[89] On this relief, several myths have been represented; the Theseus and Minotaur myth appears next to Heracles' exploits. Apparently neither twelve Theseus deeds nor twelve Heracles deeds were represented here but the two seem to have been mixed. Even if twelve panels were reserved for Heracles, in no case could the Dodekathlos have been represented. We see only the horse, Hind, and Hesperides from the canonical cycle. The Geryon adventure occupies at least two panels; thus, at least one canonic deed must have been omitted; one other deed was replaced by a non-canonic fight with a centaur.

It is reasonable to assume that the number and arrangement of the deeds in Olympia is just as accidental as in all other arrangements. From the period of the Cypselus chest up to the era of Sophocles the amount of space available for metopes determined the number of Heracles' deeds. The choice was based on local preferences and accounts for the places where we find pictures of the Augeas deed. This argument does not always hold, however. Many monuments had space for more than twelve deeds. Writers, of course, had no such limits imposed upon them.

The fact that Sophocles in his passage in the *Trachiniae* (verses 1089 ff., see p. 86) recounts only six of Heracles' deeds—lion, Hydra, centaur, boar, Cerberus, Hesperides, which

includes one outside the canon—tells us that for him the idea of a Dodekathlos was not binding.

> O my hands, my hands,
> O my back, my chest, O my poor arms, see
> what has become of you from what you once were.
> The lion that prowled the land of Nemea, that scourge
> of herdsmen,
> that unapproachable, intractable creature,
> with your strength once you overpowered it,
> and the serpent of Lerna and that galloping army
> of double-bodied, hostile beasts, violent, lawless,
> supremely strong, and the boar of Erymanthus,
> and under the earth the hell hound with three heads,
> irresistible monster, the awful Echidna's whelp,
> and guarding the golden apples the dragon at the end of
> the earth...[90]

We have a similar case in Euripides' *Heracles.* Euripides mentions eleven, or perhaps even twelve deeds, if one counts the Hesperides and Atlas as two separate adventures, and Heracles' trip over the sea as a third. Even then, however, four canonic deeds are missing: the boar, birds, Augeas, and bull. These are replaced by others (verses 360 ff., see p. 87 ff.).

> First he cleared the grove of Zeus,
> and slew the lion in its lair;
> the tawny hide concealed his back,
> oval of those awful jaws
> cowled his golden hair.

> Next the centaurs: slaughtered them,
> that mountain-ranging savage race,
> laid them low with poisoned shafts,
> with winged arrows slew them all.

> Too well the land had known them:
> Peneios' lovely rapids,
> vast plains, unharvested,
> homesteads under Pelion,
> and the places near Homole,
> whence their cavalry rode forth

with weapons carved of pine,
 and tamed all Thessaly.

And next he slew the spotted hind
whose antlers grew of golden horn,
that robber-hind, that ravager,
whose horns now gild Oenoë's shrine,
 for Artemis the huntress.

Then mounted to his car
and mastered with the bit
Diomedes' mares, that knew
no bridle, stabled in blood,
greedy jaws champing flesh,
foul mares that fed on men!
And thence crossed over
swirling silver, Hebros' waters,
on and on, performing labors
 for Mycenae's king.
And there by Pelion's headland,
near the waters of Anauros,
his shafts brought Cycnus down,
that stranger-slaying monster,
 host of Amphanaia.

Thence among the singing maidens,
western halls' Hesperides.
Plucked among the metal leaves
the golden fruit, and slew
the orchard's dragon-guard
whose tail of amber coiled the trunk
untouchably. He passed below the sea
and set a calmness in the lives of men
 whose living is the oar.
Under bellied heaven next,
he put his hand as prop:
there in the halls of Atlas,
his manliness held up
 heaven's starry halls.

He passed the swelling sea of black,
and fought the Amazonian force
foregathered at Maeotis
where the many rivers meet.
What town of Hellas missed him
as he mustered friend to fight,
to win the warrior women's
gold-encrusted robes, in quest
for a girdle's deadly quarry?
And Hellas won the prize, spoils
of a famous foreign queen,
 which now Mycenae keeps.
He seared each deadly hydra-head
of Lerna's thousand-headed hound;
in her venom dipped the shaft
that brought three-bodied Geryon down,
 herdsman of Erytheia.

And many races more he ran,
and won in all the victor's crown,
whose harbor now is Hades' tears,
the final labor of them all...[91]

The same poet speaks in his *Alcestis* of Heracles' three fights
against the sons of Ares, Lycaon, Cycnus and Diomedes. Two
of these fights are uncanonic. The fight against Lycaon is other
wise unknown in art and literature.

Nothing therefore indicates that a cycle of twelve deeds was
known in the fifth century or earlier, or that a cycle up to that
time had been established as a canon.[92] A canonic cycle is
known in neither art nor literature of the fourth century. When
we investigate the word "Dodekathlos," we are surprised to
discover that such a word did not exist at all in antiquity.
Similar words turn up for the first time in the Hellenistic
period, but they are rare and do not refer to a cycle of twelve
combats but to the victor of twelve fights.[93] Since this word,
"Dodekathlos," did not exist in early times it seems likely that
the concept also was unknown.

From the literature of the Hellenistic period we can be certain that the Dodekathlos was known to Theocritus and Apollonius in the third century.[94] In all probability the Dodekathlos sprang into existence under the influence of the prototype in Olympia, where the number of twelve deeds was a result of the space limitations and the twelve labors rather accidentally were represented for the first time. Normally, we would expect the deeds to be presented in the sequence determined by locality. A deed which occurred in one city normally would be followed by a deed which took place close by. The first six deeds took place in the Peloponnese and the second six outside, to the south, north, east, and west, including the underworld and Hesperides (fig. 1). This arrangement, which makes sense, was apparently made at the time of the canonization of this cycle. At Olympia, however, such is not the case, for the order had not yet been established. Only in Olympia and nowhere else was it possible to add the Augeas adventure, which is first encountered in Pindar's *Ode*. Only after Olympia, in later centuries, could it be included in the cycle. Even in the representation of the dead lion on a mosaic, we feel the influence of Olympia.[95]

Although the Dodekathlos appeared frequently in literature and art only after the third century B.C., it could not entirely replace and crowd out all the uncanonic deeds. Lucretius (5.22), for instance, knows a selection of eight deeds from the canonic twelve. Boethius (*Cons. Phil.* 4. 7) mentions exactly twelve deeds, although only seven of them are canonic. Remarkably, Augeas is missing in both cases. The rare appearance of the Augeas deed in earlier periods makes us suspect that if any deed at all has been omitted, this is the one.[96] Also in the post-Hellenistic period we find uncanonic Heracles cycles in art.[97]

We may point to the theater frieze of Delphi where the Hydra, boar, Hind, Augeas, and bull are omitted but where the centaurs, Antaeus, and sea monsters appear. On silver cups from Pompeii there are twelve deeds but Antaeus and Pholus have been added and the bull and Augeas left out. On the pilaster reliefs of the Basilica of Septimius Severus in Leptis Magna we look in vain for the Hesperides and Augeas, yet we find centaur, Antaeus, and Hesione.

V

The Transformation of Heracles' Image

Through the centuries Heracles' appearance changed. He does not wear the lion's skin or carry the club in early pictures. Later, Geometric artists depict him as a warrior with helmet and lance but without the outfit which we later recognize as his (pls. 3, 11). That does not mean that Heracles was not perceived as a fully armed warrior—rather, Geometric art in general characterized the warrior in this manner, although in the case of Heracles it preferred to omit the shield. There is no way to distinguish the hero from Iolaus except by his size (figs. 3, 6), yet the lion skin[98] was known during this period, for according to the description of the epic, it had been worn by Homeric heroes (*Iliad* 10.23.177). It does, however, indicate that art at that time did not desire to characterize the hero by means of attributes. For instance, there are no representations of Zeus with his lightning bolt or eagle from this period. Homer and later sculptors represent him this way.

Artists of the seventh century continued this practice. Heracles fights as a fully armed hoplite with helmet, spear, and shield, as do all his co-fighters (fig. 8). But as can be seen in the century before, representations appear showing him in heroic nudity (pl. 4; fig. 2) or in a costume without armor.[99] For the first time in Greek art he uses the bow as a weapon. This bow will often accompany him from now on (pl. 37; frontispiece). Surprisingly, the bow is encountered much earlier in the pictures of heroes on oriental cylinder seals. The bow was already the weapon of Heracles in the *Iliad* (5. 392) and *Odyssey* (8. 244; 9. 606 ff.). In that century the hero generally does not even wear the lion skin. After the late seventh century he no longer uses a helmet even if he is in armor (fig. 4).[100] The armor continues to appear occasionally in the sixth century, especially in Spartan pictures

(pl. 5), and also in Attic pictures and on one Caeretan hydria depicting the Hydra fight. In the later period, in his fight against Cycnus, son of Ares, Heracles even uses helmet *and* armor. As late as the beginning of the sixth century, he appears without a lion skin in Attic art (fig. 5). It seems that he wears it after the second quarter of the century but then only knotted in front of his chest (pl. 34), possibly as he wears it earlier in the east. Occasionally in this period he pulls the lion jaw over his head.[101] At the same time the club seems to become customary.[102] Soon after the lion jaw motif, the club became common. In fact it became characteristic for the hero; his weapons—bow, sword, and club—could change, for they were not restricted to a specific deed. From this time on, the lion fight must have been considered his first deed.

Monumental artists must have depicted him in a similar way. We know there were many statues of Heracles, particularly for the Archaic period, but they have all vanished.[103]

One of the earliest representations of Heracles in monumental art comes from a pediment of the Acropolis in Athens (pl. 47) made soon after the Hydra pediment (fig. 5). Unfortunately, the head of the hero has not survived. The relief of the former is higher and much more fully carved than is the case with the Hydra pediment. Heracles is shown with the lion's jaw over his head, with the paws knotted in front of his chest, and here, before the middle of the sixth century, he has the appearance that became so characteristic of him later.

Heracles can be recognized easily without his weapons, even on pictures of the lion combat, where he does not, of course, wear the lion skin (pls. 1, 1; 2, 1; 5; 6). In the majority of Archaic pictures he has short hair and a beard. This type, however, only developed in the course of the sixth century. When fighting the lion, his first adventure, he is young and without beard. After the last quarter of the century he occasionally appears beardless in other deeds. This type still appeared in Archaic monumental art; a good example—again taken from a pediment—is the Heracles from Aegina.[104] The hero is shown in armor, as he has been depicted from the Geometric period on. He is shooting his arrows as in pictures of the seventh century. He wears the lion skin on his head, as seen for

the first time at the beginning of the sixth century. He appears without beard, as may have been possible in the seventh century but scarcely before the end of the sixth century.

The lion metope from Olympia, which represents him after the completion of the deed, is a huge step forward in the development of the image. The hardships stemming from the fight are still visible in his posture, as he supports his head with his arm. The Classical vase picture depicting the seated Heracles is another step forward. Heracles no longer fights nor is he visibly exhausted; he is in good condition. And he is close to achieving his goal.

In the fourth century the iconography becomes more subtle. Now Heracles can be depicted without any opponent. His strength and energy, formerly indicated by his armor or the ferociousness of his enemy, are now expressed in his athletic and muscular body. That which formerly had been outwardly projected now rests within. From now on the hero's body can scarcely be depicted more forcefully; the old monsters and opponents have lost much of their savagery (pl. 14). Thus, the decisive change in representations of Heracles occurred between the eighth and fourth centuries. Artists of later centuries were unable to add significantly to this development.

Notes

1. O. Gruppe, *Gesch. d. klass. Mythologie u. Rel. gesch.* (Leipzig, 1921). For further literature see: "Fabel," "Märchen," "Mythos," in *RE*; L.R. Farnell, *Greek Hero-Cults and Ideas of Immortality* (Oxford, 1921); E. Bethe, *Märchen, Sage, Mythus* (Leipzig, 1923); L. Radermacher, *Mythos und Sage bei den Griechen* (Vienna, Leipzig, 1938); K. Kerényi, *Die antike Religion* (Amsterdam, 1940); E. Cassirer, *The Myth of the State* (New Haven, London, 1946); H.J. Rose, *A Handbook of Greek Mythology* (New York, 1959); K. Schefold, *Myth and Legend in Early Greek Art* (London, 1966); K. Friis Johansen, *The Iliad in Early Greek Art* (Copenhagen, 1967).

2. For literature on Heracles see: Mau, v. Mercklin, Matz, II: 1048-1052. The most important discussions are: Julius Schneider, *Die zwölf Kämpfe des Herakles* (Meissen, 1888); A. Furtwängler, "Herakles in der Kunst," in Roscher's *ML*, 12 (1889-1890): 2135-2252. A separate article on Heracles proper was never published in *ML*. Euripides' *Herakles* (commentary by U. v. Wilamowitz-Möllendorf, 1889, 2nd ed., 1895; reprint, 1969); P. Friedländer, *Herakles. Sagengeschichtl. Untersuchungen* (Berlin, 1907); R. Bräuer, "Die Heraklestaten auf antiken Münzen," *Zfn* (1910); O. Gruppe, "Herakles," in *RE*, Suppl. III (Stuttgart, 1918); L. Preller, C. Robert, *Griech. Mythologie. Die griech. Heldensage* II⁴. *Die Nationalheroen* (Berlin, 1921); B. Schweitzer, *Herakles* (Tübingen, 1922); F. Kern, *Die Religion der Griechen*, I-III (1926-1938); U.v. Wilamowitz, *Der Glaube der Hellenen*, I-II (Berlin, 1931/1932); M.P. Nilsson, *Geschichte der griech. Religion* (Munich, 1941-1950); idem., *A History of Greek Religion* (New York, 1964); K. Kerényi, *The Heroes of the Greeks* (London, 1959); J.E. Fontenrose, *Python* (Berkeley, New York, 1959); S. Woodford, "Exemplum Virtutis: A Study of Herakles in Athens in the Second Half of the Fifth Century B.C." (Ph.D. diss., Columbia University, 1966); J. Schoo, *Hercules Labors* (Chicago, 1969); G.K. Galinsky, *The Herakles Theme* (Oxford, 1972); B. Berqvist, *Herakles on Thasos* (Uppsala, 1973); K. Schefold, *Götter- und Heldensagen der Griechen in der spätarchäischen Kunst* (Munich, 1978).

3. Roy A Swanson, trans., *Pindar's Odes* (Indianapolis: Bobbs-Merrill, 1974).

4. Concerning the lion combat with a sword see: Reisch, *AM* 12 (1887): 122 ff.; Beazley, *JHS* 54 (1934): 90; Haspels, *ABL*, 117, n. 1; Kunze, *Schildb.*, 99. In the picture on the black figure amphora in Rome, Villa Giulia 50 406

from the Castellani Collection (Mingazzini, pl. 65, 1), the bent sword on the ground seems to indicate that the hero tried unsuccessfully to fight the lion with this weapon before he started wrestling. I owe to B. Schweitzer the reference in Beazley, *EVP*, p. 140, where he compares this representation with the text of Aeschylus. There, Ajax, whose body was invulnerable except for one small spot, was killed. For oriental prototypes of the lion combat see: A. Moortgat, *Tammuz* (1949), 9 ff.; Kunze, *Schildb.*, 100, n. 2. For the early lion combat group from Samos see: *AA* (1930): 151, fig. 27; a copy of it is in the possession of Assimaki Zaimi, Athens: *Ass. int. studi medit.* 4 (1934): 27; v. Mercklin, *AA* (1940): 24, no. 4.

5. Kunze, *Schildb.*, 96, and Matz, *Gesch. gr. Kunst*, I, 64 are more skeptical regarding the interpretation of the early picture on the base illustrated in pl. 4; K. Schefold, *Gym.* (1954): 290, and in his *Myth and Legend* p. 123, pl. 5a. Schefold interpreted the lion fighter on the Cerameicus stand as Heracles. F. F. Jones, *Princeton Record* 26 (1967): fig. 6 considered this interpretation possible; Carter, *BSA* 67 (1972): 25 ff. According to W. Kraiker, *Neue Beitr. z. Klass. Altert*, 45, n. 46; T. J. Dunbabin, *Gnomon* (1954): 444; K. Friis Johansen, *The Iliad* 25, n. 28; B. Schweitzer, *Geometrische Kunst*, 185, pl. 214; Fittschen, *Untersuchungen*, 87 f., its identification as Heracles is questionable or improbable.

6. Hampe, *Sagenbilder*, no. 100, pl. 1.

7. Terracotta reliefs from Sunium: Stais, *Ephem.* (1917), 197; Matz, *Gesch. d. griech. Kunst*, 484, pl. 281a; Kunze, *Schildb.*, 100 Beil. Suppl. 8, 2.

8. Shield bands with the lion combat (cf. fig. 2): Kunze, *Schildb.*, 95 ff.; there examples of various conflict schemes are listed (98, n.1; Form XIIId, pl. 36, 37; Form XIVd, pl. 39; Form Vd, pl. 21). A later literary version maintains that the lion lived in the cave. Representations of the Archaic period confirm this version: two gems in Furtwängler, *AG*, pls. 17, 2 and 59; two Attic black figure lekythoi in Toronto and St. Louis, Haspels, *ABL*, 254, 4 and 5, *AJA* 44 (1940): 200, figs. 11-13; a red figure vase in Salonica (*VL*³ 140, 17). Small archaic bronzes with the lion combat: Oberlenningen, Scheufelen Collection. Jantzen, *Bronze-werkstätten* 27 nr. 28. Vienna, Kunsth. Mus. 2594. Recent literature: A. v. Salis, *BWPr* 112 (1956): 5 ff.; E. Künzl, *Frühellenist. Gruppen* (Cologne, 1968), 70 ff. Similar lion combat compositions were popular in Etruscan art from the mid-sixth century on: Loeb Tripod, Munich, Krauskopf, *Sagenkreis*, 32 f., pls. 11-12; Leningrad tripod stand, idem., pl. 6, 2; terracotta frieze plaque from Acquarossa, Östenberg, "Le terrecotte architettoniche etrusche di Acquarossa nel Viterbese," *Colloqui del Sodalizio* 2. s.2, 98 ff., pl. 31, only to mention a few examples.

9. Concerning a new interpretation of the Olympia metope see F. Brommer, *Die Wahl des Augenblicks in der griech. Kunst* (Munich, 1969), 20 ff.

10. For the later development of the lion combat motif in Byzantine art see: ivory casket in Florence Mus. naz., *CahArch* 2 (1947), pl. 13, 3; Weitzmann, *Mythology*, 157 ff.

11. See also the ivory relief from Sparta, Dawkins, *Artemis Orthia*, 212, pl. 103, 1. A list of Hydra representations is given in P. Amandry, *Bull. fac. des lettres Strasbourg* (1952): 293 ff.; Etruscan bronze cistae feet with comparisons are found in: Hamburg 1925, 185, *AA* (1928): 440, fig. 152 nr. 125; A. Rumpf, "idra," *EAA* 4 (1961): 90f.; Fittschen, *Untersuchungen*, 147 ff.; Feytmans-Callipolitis, *Ephem.* (1970): 97 ff.

12. For early stages of the Hydra combat in eastern art see: G. R. Levy, *JHS* 54 (1935): 40–53; H. Frankfort, *Cylinder Seals*, 122, pl. XXIIIj; H. Goldman, *Hesperia*, Suppl. VIII (1949): 164–174; Kunze, *Schildb.* 102f.

13. Hesiod, *Theogony*, trans., Richmond Lattimore (Ann Arbor: University of Michigan Press, 1959).

14. Hampe, *Sagenbilder* no. 101, pl. 2.

15. Hampe, *Sagenbilder* no. 135, pl. 8. Matz, *Gesch. griech. Kunst* I, fig. 4.

16. Schweitzer, *Herakles*, figs. 34, 35. Hampe, *Sagenbilder* no. 72.

17. For the sickle see: M. Nilsson, *BSA* 46 (1951): 122 ff.; for the Caeretan hydria: V. Kallipolitis, "Les hydries de Caere," *AntCl* (1955): 384 ff., no. 26; J. K. Hemelrijk, *De Caeretaanse Hydriae* (Rotterdam, 1956), no. 17; Santangelo, *MonPiot* 44 (1950): 8, fig. 6; Brommer *VL³*: 82, 16. The hydra was seldom represented in Etruscan art and is first identifiable in the second quarter of the sixth century in an olpe Berlin 1255, Krauskopf, *Sagenkreis* 18f., fig. 6.

18. Regarding the black figure bowl and the Euphronius amphora: Brommer, *MarbWPr.* (1949).

19. Concerning the hydra in Hellenistic art see: R. Exner, *MusHelv.* 8 (1951): 185–189.

20. *AA* (1941), 636, fig. 128; P. Zancani Montuoro and U. Zanotti Bianco, *Heraion* II (1954), 196 ff. On an Etruscan tripod from Vulci in Leningrad the scene differs little from the Olympia shield band, Krauskopf, *Sagenkreis* 35 and n. 229, pl. 6, 3–4. It is a relatively common theme in Etruscan art, idem., n. 230.

21. Regarding the boar metope on the Hephaisteion see: S. Benton, *JHS* 57 (1937): 39; Dinsmoor, "Observations on the Hephaisteion," *Hesperia*, Suppl. V (1941), 117 ff., figs. 44–48; the translator owes to H. A. Thompson the following note: Delivorrias, *Att. Giebelskulptur* 31 rightly dissociates from the boar metope the head previously assigned to it by Dinsmoor. Delivorrias recognized the head as that of a centaur from one of the Hephaisteion pediments.

22. Cf. M. Rostovtzeff, *AJA* 41 (1937): 93 ff.; P. Amandry, *BCH* 66/67 (1942/43): 150–156; Kunze, *Schildb.*, 104 ff.; also the metope 2A from Calydon (Dyggue, *Das Laphrion* 160f., 153, fig. 164, pl. 19, 202, 2A) described in the excavations of Temple B2 (239) and dated in the middle of the first half of the sixth century. See also Ap. Rhod., *Argon.* 1.125 ff. Relief: Marconi, *Agrigento*, fig. 134. H. V. Hermann, *Olympia* (Munich, 1972), n. 559 accepted an unlikely humorous interpretation.

23. The Odes of Pindar, trans., Richmond Lattimore (Chicago: The University of Chicago Press, 1976).

24. *Diodorus Siculus*, trans., C.H. Oldfather (Cambridge, Harvard University Press; London, W. Heinemann, Ltd., 1935).

25. L. Röhrich, *Rhein. Jb. f. Volkskunde* 10, 100/154 points to a similar Slovenian legend concerning a chamois buck with golden horns. For the hind with antlers, compare the Sophocles fragment in Jebb–Pearson fr. 89 = Nauck² fr. 86 with similar citations.

26. *Apollodorus*, trans., Sir James G. Frazer (London: W. Heinemann, Ltd., 1921).

27. Hampe, *Sagenbilder* pl. 8; Matz, *Gesch. griech. Kunst* I, fig. 4; the hunter on the Geometric gold plaque in Vienna, Staatl. Kunstgew. Mus. Inv. AM 124; Reichel, *Griech. Goldreliefs* no. 24, pl. 8; the figure throwing his spear towards the hind with a calf may be Heracles. See also Ap. Rhod., *Argon* 1.125 ff. For vase pictures with the hind see: Brommer, "Studien z. griech. Vasenmalerei," *AntK*, Suppl. 7, 51 ff. A newly discovered late Geometric vase representation, Brommer, *AA* (1977): 479–481, similar to the fibula, perhaps was intended as the capture instead of the killing. Both the fibula and vase date from the same period, end of the eighth century or beginning of the seventh century.

28. *ADA* III, pl. 44–45; more recent: M. Santangelo *Boll. d'Arte* 37 (1952): 147–172. For the scene in Etruscan bronze attachments, see: P. Zancani Montuoro, *ASAtene* 8–10 (1940/8): 93 ff.; on a helmet from Vulci in Paris, Cabinet des médailles, A. Hus, *Les bronzes étrusques* (Coll. Latomus, 139, Brussels 1975), 90, pl. 28, 1. An Etruscan amphora by the Micali Painter also illustrates the popularity of this particular theme, G. Uggeri, "Una nuova anfora del Pittore di Micali," *NumAntCl* 4 (1975): 24 ff., pl. VI. The composition is almost the reverse of the Oxford plate (pl. 23). The artist omitted Athena, and Heracles, instead of drawing his bow, only stands holding it and two arrows in his left hand and a lowered club in his right hand.

29. The tripod fight: Parke-Boardman, *JHS* 77 (1957): 276 ff.

30. Pausanias mentions an Apollo with the hind (10.13.5). Concerning this and the Apollo of the Peparethians, cf. Pomtow in *RE*, Suppl. IV, 1322, nos. 70, 71.

31. For Apollo with the stag in monumental sculpture see: the work of Kanachos, Overbeck, *Schriftquellen*, no. 403 ff. The dedication of the Macedonians at Delphi is found in Dion, *RE*, Suppl. IV, 1323, no. 71 and of the Peparethians, *RE*, Suppl. V, 109, nr. 182. For Coptic production see: A. Apostolaki, *Ephem.* (1937): 325–337. A Byzantine relief is in Ravenna: Schweinfurth, *Grundzüge*, fig. 15. Kunze, *Schildb.*, 114, 126, considered it possible that this theme was represented on shield bands. Regarding the later development of the theme see: Weitzmann, *Greek Mythology*, 158. The group of Heracles with the hind from Herculaneum, now in Palermo, has been traced to the circle of Lysippus: Neugebauer, *Katalog der Berliner Bronzen* II, 77; Lippold, *Griech. Plastik*, 284, n. 9.

32. For early literature see: Pisander fr. 4 (Kinkel), Pherecydes fr. 32. The text in which he scares them away with rattles is found in: Ap. Rhod. *Argon.* 2.1054 ff. For the kind of bird see: J.K. Anderson, *JHS* 96 (1976): 147.

33. Schweitzer, *Herakles,* 167, and Hampe, *Sagenbilder,* 40, have rejected the older interpretation of the fibula picture as the Stymphalian birds, expressed by Reisinger, *JdI* 31 (1916): 303. Nothing supports the idea that the figures portrayed with the Stymphalian birds are female. Since both hold birds, it is improbable that only one is a divinity. Since oriental artists had already produced similar mythological representations (Frankfort, *Cylinder Seals,* 198, pl. 34c; Moortgat, *Vorderasiat Rollsiegel,* pl. 73, 613) it is not surprising to find this legend in Greek Geometric art. The mythological interpretation of the fibula picture has been accepted by Schweitzer, *Geometrische Kunst,* 228. It is rejected by Hampe, *Löwenschale,* n. 85, pl. 19, and Simon, *Götter,* 240. Basically there is no difference between the picture on the fibula and that on the Munich lekythos (pl. 27).

34. The mythological interpretation of the Geometric jug picture is accepted by: K. Schefold, *Gymn.* (1954): 290; W. Kraiker, *Neue Beitr. z. Klass. Atertumswiss.* 46, n. 47 and 49; V.H. Poulsen, *Meddelelser Ny Carlsberg Glypt.* 11 (1954): 34; Ch. Picard, *RA* (1956): II, 96; Twele, *AJA* 81 (1977): 105. This interpretation has been considered possible by: T.B.L. Webster, *CR* 5 (1955): 114f.; L. Lacroix, *RBPhil* 32 (1954): 1218; Schefold, *Myth and Legend,* 23, pl. 5b; F.F. Jones, *Princeton Record* 26 (1967), fig. 7; Schweitzer, *Geometr. Kunst,* 349, n. 63. The interpretation has been questioned by: K. Friis Johansen, *The Iliad,* 25, n. 28; Schauenburg, *Jagd.,* 21; Schweitzer, *Geometr. Kunst,* 58, however, cf. p. 349, n. 63; Carter *BSA* 67 (1972): 52; opposed, Fittschen, *Untersuchungen,* 65.

35. H.A. Thompson, *Hesperia* 17 (1948), 174f., pl. 50 considers a marble fragment from the Agora to be the head of a bird; he relates it to the Heracles head found at the same spot and both to the adventure of the Stymphalian birds. The later development: Weitzmann, *Greek Mythology,* 161.

36. Augeas: M. Floriani Squarciapino, *ArchCl* 10 (1958): 106 ff.; Ashmole-Yalouris-Frantz, *Olympia,* 29; J.M. Balcer, *AJA* 78 (1974): 149, saw in the Mycenaean dike at Tiryns evidence for the historic beginning for the story. Cf. P.W. Wallace, "Herakles and the dikes," *AJA* 78 (1974): 182.

37. We cannot explain that the Augeas adventure is the only one of the twelve missing from Greek vase pictures by the fact that "the action of the story resists displaying a clear pictorial visualization," (Friedländer, op. cit, 130). In view of the larger number of monuments available now, the omission of this deed is even more puzzling today than it was four decades ago; cf. n. 96 below.

38. Overbeck, *Schriftquellen,* no. 1478 ff.; Kleiner, "Alexanders Reichsmünzen," *AbhBerlAk* (1949): 17.

39. Acusilaus in Apollod. 2.94. Greek relief in Rome, Barracco Coll., *Coll*

Barracco, 58, pl. 51 b.; Helbig⁴ II, 1908; Brendel, *RM* 45 (1930): 215 ff., pl. 82. The interpretation of the figures as Theseus *and* Heracles may point to the conflation of the two heroes in the fourth century, as both fight similar bulls.

40. Killing the bull with a club was already familiar in oriental art: Wetzel, *Assur and Babylon*, 9, fig. 2, with matching citation from the Gilgamesh epic. Cf. the representations on the didrachma reverses from Selinus of the fifth century: Regling, *Münze als Kunstwerk*, pl. 17, 385; ibid., Warren Collection, pl. 7, 289, 290; Gardner, *Types* pl. 2, 17; Seltman, *Greek Coins*, pl. 24, 8.

41. Relief from Sunium: *Hesperia* 10 (1941): 163 ff., fig. 3, no. 3. For further literature on the bull see: U. Hausmann, *Hellenist. Reliefbecher* (1959): 69 ff.; H. Borbein, *RM* 14 (1968): 172 ff.

42. R. Pfeiffer pointed out to the author that a Pindar fragment mentioned the horses of Diomedes: *Oxyr. Pap.* 26 (1961): 141 ff., no. 2450; cf. D.S. Kurtz, *JHS* 95 (1975): 171 f.

43. *Alcestis*, trans., Richmond Lattimore (Chicago, The University of Chicago Press, 1955–59).

44. Archaic gems: Beazley, *Lewes House Gems*, pl. 2, no. 21; Furtwängler, *AG*, pl. 6, 47 and pl. 8, 59.

45. *BCH* 47 (1923): pls. 16–18 N3.

46.˙ For the head of the horse from the metope in Olympia see: *Enc. Phot.* (Ed. TEL 1938), no. 25, pl. 156, after that, Kähler, *Metopenbild*, pl. 68.

47. Supra, note 41. For the later development see: Weitzmann, *Greek Mythology*, 162.

48. Ap. Rhod. *Argon.* 2, 780f., 971; Plautus, *Menaechmi* 200.

49. The shield from Tiryns (here pl. 3) is first illustrated in Lorimer, *BSA* 42 (1947): 133 ff., pl. 18 A a and *Homer and the Monuments* (1950), 170, pl. 9, 1. (A fragment from the earlier period is in Pfuhl, *MuZ*, fig. 23 b.) Their argument against a doubtful interpretation as Heracles is not convincing in view of the examples offered here; Schefold, *MusHelv.* 3 (1946): 92 interpreted the picture on the shield as Heracles. He suspects (ibid., 93) that the Amazon fight of Heracles had appeared on a pediment of the Athenian Treasury as well as on a pediment from Thebes; L. Curtius, *AM* 30 (1905): 375 ff., pl. 13. The shield has also been interpreted as Heracles by Matz, *Gesch. griech. Kunst* I, 68; Kunze, *Schildb.*, 51, 151, n. 1; W. Kraiker, *Neue Beitr. z. Klass. Altert.*, 47, n. 50; Ch. Picard, *RA* (1956): II, 96; and Schefold, *Myth and Legend*, 24, pl. 76; idem., *Acc. Lincei Quaderni*, 139, 94; Hampe, *Die Gleichnisse Homers*, 30, 38, n. 23, fig. 21, advocates the same interpretation as Lorimer.

Achilles was proposed by T.B.L. Webster, *Lustrum* (1956): 100; R. Hampe, *GGA* 20 (1968): 20; Fittschen, *Untersuchungen*, n. 848; undecided: F.F. Jones, *Princeton Record* 26 (1967): fig. 11.

50. Inscribed Andromache: Tyrrhenian amphora in Boston, *AJA* 48 (1944): pl. 3; Attic black figure neck amphora in Cambridge *CVA*, pl. 8/9; the same

also appears on Tarquinia RC 5564 (Photo Moscioni 8631). Compare also the related inscription, "Andromeda," (here fig. 8) and the inscription, "Antimache" on the black figure fragment, *Akrop. Vas.* I, no. 1781, pls. 83 and 86.

51. Brommer, *VL³* 24, 5; and an Apulian calyx krater 1977 on the art market.

52. The group in Olympia was made before 494 B.C. Amazon on horseback: a tondo in the Vatican, Bielefeld, *Amazonomachia*, fig. 1, and a mirror in the Berlin Museum, Züchner, *Klappspiegel*, pl. 26, no. 73; in addition, von Bothmer, *Gnomon* 24 (1952): 198.

53. For the metope from Selinus see: E. Benndorf, *Metopen*, pl. 7; Winter, *KiB* 245, 2. Richter, *Sculpture and Sculptors* (1950), fig. 412; Curtius, *Antike Kunst*, figs. 342, 346; Gerke, *Griech. Plastik*, pl. 132; Marconi, *Il museo naz.*, fig. on p. 35; Fröber, 76, fig. 41; Alinari 19 582; Kähler, *Metopenbild*, pl. 55; cf. Mausoleum frieze, London, Brit. Mus. 1008. Relief in Tarento: Klumbach, *Tarentiner Grabkunst*, no. 43.

54. Payne, *Perachora*, pl. 50, 4/5; Kunze, *Schildb.* 122, interpreted it as Geras. Beazley, *BVAB* 24/26 (1949/51): 18, suspected in the sacrifice of Heracles, an Amazon. Against the interpretation as Geras see also: Brommer, *AA* (1952): 67, n. 6, fig. 4.

55. Pindar, fragment 169 (151). Hecataeus, fragment 349 in Arrian, *Exped. Al.* 2.16. On the *Geryoneis* s.v. Robertson, *ClQ* 19 (1969): 207–221; Boardman, *AntK* 19 (1976): 13.

56. Shield bands from Delphi and Olympia are published in: *FdD* 5, pl. 21, text p. 123. v. Massow, *AM* 41 (1916): 61, fig. 14, p. 77; Friis Johansen, *Les vases sic.*, 144; Payne, *NC*, 130; Kunze, *Schildb.*, 106 ff. An Etruscan representation of this adventure survives from the first quarter of the sixth century on an ivory pyxis from the Pania necropolis in Clusium in the Florence Archaeological Museum, Cristofani, *StEtr* 39 (1971). Although the figure of Heracles is missing in the damaged fragments, a large cattle herd is shown guarded by the three-bodied giant. A krater from Cerveteri in the Villa Giulia Museum, Rome, shows Heracles with bow and arrow attacking Geryon and is dated ca. 540 B.C., Krauskopf, *SagenKreis*, 26, pl. 16.

57. See Brommer *VL³*, 63, C 1,2: A. Rumpf, "Gerione," *EAA* III (1960): 845 f.

58. The earliest Attic vase representation is on the hydria of Lydos in the Villa Giulia 50 683, Beazley, *Development*, 48.

59. P.G.P. Meyboom, "Some observations on narration in Greek art," *Mededeling* 40 (1978): 62 and n. 107.

60. *Hesperia* 10 (1941): 173, fig. 5; 187, scene 3, 6.

61. Apulian volute krater: Berlin F 3258, see Brommer *VL³*, 63 D1. For the later development of the myth see: Weitzmann, *Greek Mythology*, 120 ff.

62. It is described in Apollod. 2.107.

63. It is illustrated in Haspels, *ABL*, 120.

64. Concerning the localization of Cerberus in Pontus see: Xenophon, *Anabasis* 4.2.2; *Diod.* 14.31; Ap. Rhod., *Argon* 2.735 ff.; for further literature on Cerberus see: Robinson, *Hesperia,* Suppl. VIII, 313 ff.; Cook, *Zeus* III, 408 ff.; Roux, *Mélanges Picard* II, 896–904; G. Sgatti, "Cerbero," *EAA* II (1959): 505 f.; E.T. Vermeule, *Festschrift F. Brommer,* 299, proposed Egyptian multiple-headed dog representations as possible prototypes for Cerberus iconography. On the number of heads: idem., n. 24.

65. For vase representations with Cerberus see: Brommer, "Studien z. griech. Vasenmalerei," *AntK*, Suppl. 7, 50 ff.; *VL³*, 91 ff.

66. K. Friis Johansen, *OpRom* 4 (1962): 64 ff.; Brommer, *VL³*, 96 C 1, 2.

67. For the subduing of Cerberus see: Brommer *VL³*, 92 A 23. For the negotiation see: Brommer *VL³*, 92, 8.

68. Group from the Acropolis: Payne-Young, pl. 124, 4; Langlotz-Schuchhardt, no. 415.

69. Marble base, Athens NM 42 and 3579, *AM* 66 (1941): pl. 64. Concerning the construction of the base see: O. Walter, *MdI* 3 (1950): 139. In this context see the relief from Tarento: Klumbach, *Tarentiner Grabkunst,* 59 nr. 42, 170.

70. Pherecydes in Schol. Apollon. 4.1936 *FGH* I, 33. Heracles and Atlas on Etruscan gems: Hanfmann, *StEtr* 10 (1936): 399–405. The same theme appears on Etruscan mirrors: Beazley, *JHS* 69 (1949): 3.

71. Hesperides: Brommer, "Esperidi," *EAA,* III (1960): 443 f.

72. Heydemann, 30. *BWPr,* fig. 1. Brommer, *JdI* 57 (1942): 113, fig. 7. Brommer, *Satyrspiele,* 73, no. 92. Van Hoorn, *Choes,* no. 642, fig. 145.

73. The picture on the alabastron in Nauplia (pl. 44) appears to be partially modern.

74. British Museum 244; Brommer *VL³*, 72 B5.

75. Coin from Cyrene: *JdI* 57 (1942): 121, fig. 13; Cahn, *Griech. Münzen archäischer Zeit* (1947), 15, fig. 19, is the best illustration up to now. The date "about 540 B.C." is too high.

76. For monumental art: *JdI* 57 (1942): 120 ff.

77. Hephaisteion metope: Kraiker-von Schönebeck, *Hellas,* pl. 27; Kähler, *Metopenbild,* pl. 47 interpreted it as Athena and Heracles; H.A. Thompson earlier in *Hesperia* 18 (1949): 230 ff., pl. 64, interpreted it as a Hesperid and Heracles but now favors Athena; cf. C.H. Morgan, *Hesperia* 32 (1963): 212. In 1949, he felt that the fragments from the east pediment of the Hephaestus temple also related to the Hesperides legend. Götze, *JdI* 63/4 (1948/9): 98, interpreted the metope as Hera and Heracles. P. Lévêque, *BCH* 74 (1950): 224–232, pl. 34, links his interpretation of new fragments from the theater frieze in Delphi to the Hesperides legend.

78. H. Götze, *Festgabe z. Leipz. Winckelmannsfeier* (1937), title page; idem.,

RM 53 (1938): 235, fig. 6; idem., *JdI* 63/4 (1948/9): fig. 4. H.A. Thompson, *Hesperia* 21 (1952): 47–82 linked the Hesperides relief together with the other Attic three-figure reliefs to the walls surrounding the Altar of Pity in Athens. Although he expressed in a communication to the translator the belief that the Altar of Eleos was distinct from the Altar of the twelve Gods, Professor Thompson continues to associate the original of the Hesperides relief with the Altar of the twelve Gods; cf. *The Athenian Agora: Guide*, 3rd ed. (Princeton, 1976), 96–98; cf. Helbig⁴ IV, 3247.

79. Concerning the monuments with cycles of twelve deeds see particularly: G. Lippold, "Das Herakles-Mosaik von Liria," *JdI* 37 (1922): 1–17.

80. The mosaic is also depicted in: *Adquisiciones del museo arqueologico nacional* (Madrid, 1947), pl. 48; *AJA* 53 (1949): 156, pl. 24; *Ars Hispaniae* II (Historia universal del arte hispanico): fig. 152.

81. In ancient literature, Diod. (4.11-27, see 4, p. 00) in the first century B.C., Apollodorus, *Bibliotheca* (2.74-126, see 5, p. 00) and Hyginus (*Fab.* 30) in the second century A.D. report the stories of the Dodekathlos in minute detail. The authors vary on several details and often include additional stories. In most cases we do not know the written sources they used or how far back their information could be traced. All other detailed descriptions are lost. Occasionally certain supplements are available [e.g., *Herakles* by Euripides (5.360 ff., see 9, pp. 00 ff.) and the *Trachiniae* by Sophocles (5.1089 ff., see 8, p. 00) or short accounts as Anth. Planud. 4.92; Albanian Tablet; Lucretius, 5.22 ff.; Ausonius, Ed. 19].

82. Concerning the date of the development of the Dodekathlos: v. Wilamowitz, *Herakles*², I (1895), 55 ff.: Argos, eighth century; A. Furtwängler in Roscher's *ML*, I, 2 (1886–1890): 2242: "In the art of the fifth century the cycles of Herakles deeds spring into existence;" 2251: "After Alexander the canon . . . can be observed;" Robert, *BWPr* 50 (1890): 88 ff., n. 3: "Before Matris no one knew anything about a cycle of twelve Herakles deeds. In Olympia the number twelve has been determined solely by the number of metopes;" Friedländer, *Herakles*, I (1907): sixth century at the latest; A. Frickenhaus, *Tiryns*, I (1912), 126 ". . . older than Temple C" which on p. 13 he considers pre-sixth century; K. Regling, *Amtl. Ber. Preuss. Kunstslg.*, 40 (1919), 278: ". . . Dodekathlos made by the Hellenistic scholars in their predilection for canonic fixations from the rich cycle of Herakles legends;" Gruppe, *RE*, Suppl. III (1919), 1021: the Dekathlos is very old, the Dodekathlos is very young; Schweitzer, *Herakles* (1921), 179: certainly towards the end of the seventh century at the earliest; Preller-Robert⁴ (1921), 435 ff.: fifth century? Pherecydes? Lippold, op. cit. (1922), 3 ff.: sixth century? much earlier than the Olympia metopes; Buschor, *Skulpturen des Zeustempels zu Olympia*, text (1924), p. 22: Olympia metopes are the first example; Nilsson, *Minoan-Mycenaean Religion* (1927), 547: Mycenaean period; Nilsson, *The Mycenaean Origin of Greek Mythology* (1932), 213: "The canonical cycle of twelve may as such be rather late, but in principle it is old, and, as the myth giving the reason why Heracles performed the labors, clearly, is proved to belong to the Mycenaean age, the same must

be true of the cycle as a whole, but not necessarily true of every labor;" Rose, *Handbook of Greek Mythology* (1928), 210: "cycles... probably... not... as old as Homer;" (Hege)-Rodenwaldt, *Olympia* (1936), 43: old Epic; Rostovtzeff, *AJA* 41 (1937): 93 ff.: logographers? Dornseiff, *Der sog. Apoll von Olympia* (1938), 39, n.1: ancient, not originally Greek; G. Becatti, *Critd'Arte* 4 (1939): 15-16: "... in realtà nessuna prova sicura abbiamo per ammettere un'origine arcaica sia letteraria sia monumentale;" Schmidt-Stählin, *Gesch. griech. Lit.*, VII, 1.3 (1940), p. 432, n.2: probably fifth century, perhaps before Pherecydes; Nilsson, *Gesch. griech. Rel.* (1941): 14: a lost epic is not impossible; Wrede, *AM* 66 (1941): 164: "The Dodekathlos poem was popular in finished form in the sixth century;" E. Buschor, *Bronzekanne* (1943), 29: the Dodekathlos was "... summed up for the first time in the twelve metopes from Olympia;" Dornseiff, *Archiv f. Orientforschung* 14 (1944): 324 ff.: oriental; Zancani Montuoro, *Atti Acc. Lincei* (1947): 210: end of the seventh century or beginning of the sixth; Curtius, *Interpretationen* (1947): 57: writing of the sixth century; U. Hausmann, *Hellenist. Reliefbecher* (1959): 99: "The canonization of the Dodekathlos is supposed to go back to Alexander;" K. Schauenburg, *Philologus* (1960): 10, n.1.: "not at all against a pre-Hellenistic development." H. Sichtermann, *EAA* III (1960): 378 ff.: Dodekathlos "nel primo periodo classico;" the Deeds "non presentano un ordine fisso né nel periodo remoto ne in quello tardo;" W.H. Schuchhardt, *Festschrift für Hugo Friedrich* (1965), 241 ff.: known since the eighth century; W. Pötscher in *KlPauly* (1967), 1050: Athloi "already standardized to twelve in the early classical period." It is astonishing that after Robert in 1890 had correctly stated the facts, and numerous new monuments have subsequently proven his view in recent times, in handbooks, such incorrect statements can be discovered, as the last three above which contradict one another. Still undecided is H.V. Hermann, *Olympia* (1972): 142: "We do not know whether a cycle of twelve Herakles adventures had already existed then or if it had been created only in the metopes of Olympia." In his article "Herakles" in *RE,* Suppl. XIV (1974), 137-196, Prinz seizes on the archaeological evidence without further search (138) and accepts "a canon of labors" for the Archaic period (169). Prinz does feel there is no strong connection between Eurystheus and the selection of twelve labors (171). F.F. Jones, *Princeton University* (1975): 2, conjectures that the canon came into existence at the turn of the seventh to sixth centuries.

83. On the Corinthian cup, *Perachora*, II, no. 2542, pls. 106, 110, 163, the lion, Geryon and Cecrops labors are preserved; among them one is uncanonic. A krater of the Cleophrades painter, Greifenhagen, *SbHeid* 1972, displays the Amazons, hydra, Geryon and the Hesperides. Represented on a relief vessel in Bern are the lion, hydra, boar, hind, bull, Amazons, Cerberus(?) and Pholus. It lacks the birds, Augeas, horses, Geryon.

84. Concerning the arrangement of the metopes on the Athenian treasury see: de la Coste-Messelière, *BCH* 47 (1923): 396 ff. and in his footsteps, Schefold, *MusHelv* (1946): 73. Kähler explains "... a slab (relief) with a scene as a Gigantomachy," which de la Coste (p. 403) with more careful consideration thought "a victory of Herakles over a giant." The latter left the identification

of the giant as Antaeus open. On the other hand only one Gigantomachy scene within a series of Heracles deeds is impossible. Lippold, *Griech. Plastik*, 82 raises the question of "a giant?"

85. P. de la Coste-Messelière, *BCH* 90 (1966): 699 ff. earlier interpreted the representation of the metope on the Athenian treasury as the tripod combat, but later changed his mind and attributed this fight to the Doric temple, Marmaria. Although the Delphic tripod theme is still uncertain on the Athenian Treasury metope no. 18, it could scarcely have been missing.

86. The twelve Olympia metopes do not display the order which later became canonic. Thus one could conclude (most recently B. Ashmole in *Ashmole-Yalouris-Frantz, Olympia*, 24) that the alleged original order had been altered during some later restoration. I propose that the canonic order did not yet exist at the time of the Olympia metopes. A later period—the later, the less likely—would not have destroyed a canonic order, on the contrary, it would have tried to recreate it. Ashmole in *Architect*, 64 abandoned this view.

87. In the early fragmentary literature there are no hints of a Dodekathlos. Cerberus, Geryon and Cycnus survive in Stesichorus; the latter does not belong in the canonic deeds. For the Heracles cycles see: Kähler, *Metopenbild*, 36, 49, 76.

88. The figure twelve for Alyzia suspected by Lippold, "Lysippos," *RE*, XIV, 52 and G. Kleiner, "Alexanders Reichsmünzen," *AbhBerlAk* (1949): 17, 45 is not given. Cf. Möbius, *AntPl* X, 46.

89. *Supra*, note 41.

90. *Sophocles*, trans., M. Jameson (Chicago: The University of Chicago Press, 1954-55).

91. Euripides, *Herakles*, trans., William Arrowsmith (Chicago, The University of Chicago Press, 1955-59).

92. We can only stress that there is no basis for believing a cycle of twelve deeds existed in the fifth century or earlier.
A chart of the vase pictures at present (June 1982) known to us and representing Heracles labors offers the following statistics:
This chart reveals that the Augeas deed (VI) does not exist on vase pictures and that the lion fight (I) constitutes the most popular deed. Since not only the rubric A and C but also a large part of B is restricted to the Archaic period, we can deduce that most vase pictures with Heracles deeds had been made by then. The adventure with the Stymphalian birds (V) is not known at all from post-Archaic vase pictures, that with the hind (IV) is rare.
Although we now know of more objects depicting the adventures since the author's initial publication (1953), the ratio of individual legends to each other remains essentially the same.
If one consults the other pictorial representations of Heracles deeds we cannot find one scene of the Augeas adventure outside vase painting before the Hellenistic period—except the Olympia metope. Other than this

example, there is no pictorial Dodekathlos before the Imperial period. During the empire, however, these cycles are very common (Brommer, *DL* I, 1-13). The lion combat is again the most popular deed on monuments other than vases, but the representations from the classical period to late antiquity now add up to half the number of Archaic vase pictures depicting this theme. Considering the wealth of monuments discussed our judgments cannot be accidental.

93. The sources for (insert Greek) and (insert Greek) according to Liddell-Scott: Preisigke, Sammelbuch 2134.4 (tomb inscription of the Antonine period), APL 4.99 and Nonnos, D.35.335.

94. For the complete Dodekathlos in literature see: Theocritus, *Herakliskos.*—Ap. Rhod. *Arg.* 1.1317.—Hyginus, *Fab.* 30. APL 4.92.—Albanian Tablet.—Ausonius, Ed. 19.

95. Mosaic: *Annali* (1862): pl. Q.

96. When Büchner in his translation of Boethius (*Slg. Dieterich,* 176, n. 131) comments, "The Augeas stable has been omitted because this adventure would not have matched the stylistic achievement," he does not explain why Boethius also omitted the hind, bull, Amazon and Geryon in favor of other deeds. Supra, note 37. H.H. Huxley, *Proceed. Leeds Philos. Soc.* 7 (1952): 20-30, remarks for Roman literature: "rarely does a poet mention in one passage all twelve feats; rarely are the tasks imposed by Eurystheus separate from the 'parerga' . . ."

97. Lucian, *Iupp. Trag.* 21 mentioned the hydra, birds, horse, centaurs; of four, one is uncanonic. Fulgentius, *Metaforalis* (Liebeschütz 124), indeed, named twelve labors, only five of which were canonic. For the theater frieze in Delphi see: P. Lévêque, *BCH* 75 (1951): 247-263. Lévêque recognizes the following deeds: Hesperides, Cerberus, lion, centaurs, Hydra, Antaeus, Amazons, Geryon, horses, birds; he dated it in the first century B.C.

Amandry, *Bull. Fac. d. Lettres Strasbourg* 30 (1952): 306 f. contests, for good reason, the interpretation of the hydra and substitutes a sea monster.

Pilaster reliefs from Lepcis Magna: Squarciapino, *Scuola di Afrodisia,* 89 f., pls. 28, 30; Amandry, op. cit., 307, no. 95. Concerning the mosaic from Piazza Armerina in Sicily, G.V. Gentili's *Times* (December 11, 1951), *Ill. London News* (December 22, 1951 and March 8, 1952) and *NSc* (1950): 306 descriptions do not make it clear if Augeas and the birds are omitted, because of the poor state of preservation. A sea monster seems to have entered the cycle even in this example.

98. For Heracles with the lionskin see: Furtwängler in Roscher's *ML,* 2145; Rumpf, *Chalk. Vasen,* 143; Kunze, *Schildb.,* 95, n.1. The Melian amphora often cited in this connection and previously dated in the seventh century has been dated by Schefold c. 600 (Pfuhl-Schefold, *1000 Jahre griech. Malerei,* fig. 110). It might just as well have been made at the beginning of the sixth century and consequently is scarcely earlier than the Attic pictures of Heracles with the lionskin. The Chios Heracles is much later than the Melian amphora (ibid., fig. 119).

99. Heracles with costume but without armor: on the Nessus vases in New York and Athens (*JHS* 32 (1912): pl. 10 and Pfuhl, figs. 85, 86, 87, 89).

100. An armored Heracles: Kunze, *Schildb.*, 94, n. 2.

101. The "Tyrrhenian" amphora in Boston, *AJA* 48 (1944): pl. III belongs to the earliest Attic pictures depicting Heracles with the lion jaws pulled over his head.

102. On shield bands Heracles carries the club in the following adventures: (Kunze *Schildb.*, 95) lion, Nessus, Antaeus, "Geras," Apollo, Hesperides, Cecrops.

103. Heracles in Archaic sculpture: four works of Daedalus in Thebes, Corinth, Pisa and at the border of Messenia and Arcadia (Overbeck, no. 99-102); two works by Dipoenus and Scyllis in Sicyon and Tiryns (Overbeck, *Schriftquellen*, no. 321, 325); one work by Theocles and one by Medon (?) in Olympia (idem., no. 328, 330), etc.

104. Heracles on the pediment from Aegina: Furtwängler, *Aegina* 250 K, pl. 95; *50 Meisterwerke der Glyptothek*, pl. 9; Welter, *Aegina*, 86, fig. 77; Gerke, *Griech. Plastik*, pl. 73-75; Picard, *La sculpture grecque du 5. siècle*, pl. 6; Richter, *Archaic Greek Art*, fig. 249; Lippold, *Griech. Plastik*, pls. 31, 2.

Appendix
Greek Texts

Pindar, *Nemean Odes* 1, 49–112

<div align="right">

ἐγὼ δ' Ἡ-

</div>

ρακλέος ἀντέχομαι 50
προφρόνως
ἐν κορυφαῖς ἀρετᾶν
μεγάλαις, ἀρχαῖον ὀτρύνων λόγον,
ὡς, ἐπεὶ σπλάγχνων ὕπο ματέρος αὐ-
τίκα θαητὰν ἐς αἴγλαν παῖς Διὸς 55
ὠδῖνα φεύγων διδύμῳ
σὺν κασιγνήτῳ μόλεν,
ὥς τ' οὐ λαθὼν χρυσόθρονον
Ἥραν κροκωτὸν σπάργανον ἐγκατέβα,
ἀλλὰ θεῶν βασίλεα
σπερχθεῖσα θυμῷ πέμπε δράκοντας ἄφαρ. 60
τοὶ μὲν οἰχθεισᾶν πυλᾶν
ἐς θαλάμου μυχὸν εὐ-
ρὺν ἔβαν, τέκνοισιν ὠκείας γνάθους
ἀμφελίξασθαι μεμαῶτες· ὁ δ' ὀρ-
θὸν μὲν ἄντεινεν κάρα, πει- 65
ρᾶτο δὲ πρῶτον μάχας,
δισσαῖσι δοιοὺς αὐχένων
μάρψαις ἀφύκτοις χερσὶν ἑαῖς ὄφιας.
ἀγχομένοις δὲ χρόνος
ψυχὰς ἀπέπνευσεν μελέων ἀφάτων. 70
ἐκ δ' ἄρ' ἄτλατον δέος
πλᾶξε γυναῖκας, ὅσαι
τύχον Ἀλκμάνας ἀρήγοισαι λέχει.
καὶ γὰρ αὐτὰ ποσσὶν ἄπεπλος ὀρού-
σαισ' ἀπὸ στρωμνᾶς ὅμως ἄ- 75
μυνεν ὕβριν κνωδάλων.
ταχὺ δὲ Καδμείων ἀγοὶ χαλ-
κέοις σὺν ὅπλοις ἔδραμον
ἀθρόοι

ἐν χερὶ δ' 'Αμφιτρύων
κολεοῦ γυμνὸν τινάσσων ‹φάσγανον› 80
ἵκετ', ὀξείαις ἀνίαισι τυπείς.
τὸ γὰρ οἰκεῖον πιέζει πάνθ' ὁμῶς·
εὐθὺς δ'ἀπήμων κραδία
κᾶδος ἀμφ' ἀλλότριον.
ἔστα δὲ θάμβει δυσφόρῳ 85
τερπνῷ τε μειχθείς· εἶδε γὰρ ἐκνόμιον
λῆμά τε καὶ δύναμιν
υἱοῦ· παλίγγλωσσον δέ οἱ ἀθάνατοι
ἀγγέλων ῥῆσιν θέσαν.
γείτονα δ' ἐκκάλεσεν 90
Διὸς ὑψίστου πρόφατον ἔξοχον,
ὀρθόμαντιν Τειρεσίαν· ὁ δὲ οἱ
φράζε καὶ παντὶ στρατῷ, ποί-
αις ὁμιλήσει τύχαις
ὅσσους μὲν ἐν χέρσῳ κτανών, 95
ὅσσους δὲ πόντῳ θῆρας ἀϊδροδίκας,
καί τινα σὺν πλαγίῳ
ἀνδρῶν κόρῳ στείχοντα τὸν ἐχθρότατον
φᾶσέ νιν δώσειν μόρον.
καὶ γὰρ ὅταν θεοὶ ἐν 100
πεδίῳ Φλέγρας Γιγάντεσσιν μάχαν
ἀντιάζωσιν, βελέων ὑπὸ ῥι-
παῖσι κείνου φαιδίμαν γαί-
ᾳ πεφύρσεσθαι κόμαν
ἔνεπεν· αὐτὸν μὰν ἐν εἰρή- 105
νᾳ τὸν ἅπαντα χρόνον
‹ἐν› σχερῷ
ἡσυχίαν καμάτων
μεγάλων ποινὰν λαχόντ' ἐξαίρετον
ὀλβίοις ἐν δώμασι, δεξάμενον 110
θαλερὰν "Ηβαν ἄκοιτιν καὶ γάμον
δαίσαντα πὰρ Δὶ Κρονίδᾳ,
σεμνὸν αἰνήσειν νόμον.

Hesiod, *Theogony* 313 ff.

τὸ τρίτον "Υδρην αὖτις ἐγείνατο λυγρ' εἰδυῖαν
Λερναίην, ἣν θρέψε θεὰ λευκώλενος "Ηρη
ἄπλητον κοτέουσα βίῃ 'Ηρακληείῃ.
καὶ τὴν μὲν Διὸς υἱὸς ἐνήρατο νηλέϊ χαλκῷ
'Αμφιτρυωνιάδης σὺν ἀρηιφίλῳ 'Ιολάῳ
'Ηρακλέης βουλῇσιν 'Αθηναίης ἀγελείης.

Pindar, *Olympian Odes* 3, 25-30

δὴ τότ' ἐς γαῖαν πορεύεν θυμὸς ὦρμα 25
'Ιστρίαν νιν· ἔνθα Λατοῦς
ἱπποσόα θυγατήρ
δέξατ' ἐλθόντ' 'Αρκαδίας ἀπὸ δειρᾶν
καὶ πολυγνάμπτων μυχῶν,
εὖτέ νιν ἀγγελίαις
Εὐρυσθέος ἔντυ' ἀνάγκα πατρόθεν 30
χρυσόκερων ἔλαφον
θήλειαν ἄξονθ', ἄν ποτε Ταϋγέτα
ἀντιθεῖσ' 'Ορθωσίᾳ ἔγραφεν ἱεράν.

Diodorus 4.12.13

Μετὰ δὲ ταῦτ' ἔλαβε πρόσταγμα τὴν χρυσόκερων μὲν οὖσαν
ἔλαφον, τάχει δὲ διαφέρουσαν, ἀγαγεῖν. τοῦτον δὲ τὸν ἆθλον
συντελῶν τὴν ἐπίνοιαν ἔσχεν οὐκ ἀχρηστοτέραν τῆς κατὰ τὸ
σῶμα ῥώμης. οἱ μὲν γάρ φασιν αὐτὴν ἄρκυσιν ἑλεῖν, οἱ δὲ διὰ
τῆς στιβείας χειρώσασθαι καθεύδουσαν, τινὲς δὲ συνεχεῖ
διωγμῷ καταπονῆσαι· πλὴν ἄνευ βίας καὶ κινδύνων διὰ τῆς κατὰ
τὴν ψυχὴν ἀγχινοίας τὸν ἆθλον τοῦτον κατειργάσατο.

Apollodorus 2.5.3

τρίτον ἆθλον ἐπέταξεν αὐτῷ τὴν Κηρυνῖτιν ἔλαφον εἰς Μυκήνας
ἔμπνουν ἐνεγκεῖν. ἦν δὲ ἡ ἔλαφος ἐν Οἰνόῃ, χρυσόκερως, 'Αρτέ-
μιδος ἱερά· διὸ καὶ βουλόμενος αὐτὴν 'Ηρακλῆς μήτε ἀνελεῖν
μήτε τρῶσαι, συνεδίωξεν ὅλον ἐνιαυτόν· ἐπεὶ δὲ κάμνον τὸ
θηρίον τῇ διώξει συνέφυγεν εἰς ὄρος τὸ λεγόμενον 'Αρτεμίσιον,
κἀκεῖθεν ἐπὶ ποταμὸν Λάδωνα, τοῦτον διαβαίνειν μέλλουσαν
τοξεύσας συνέλαβε, καὶ θέμενος ἐπὶ τῶν ὤμων διὰ τῆς
'Αρκαδίας ἠπείγετο· μετ' 'Απόλλωνος δὲ "Αρτεμις συντυχοῦσα
ἀφῃρεῖτο, καὶ τὸ ἱερὸν ζῷον αὐτῆς κτείνοντα κατεμέμφετο.
ὁ δὲ ὑποτιμησάμενος τὴν ἀνάγκην, καὶ τὸν αἴτιον εἰπὼν
Εὐρυσθέα γεγονέναι, πραΰνας τὴν ὀργὴν τῆς θεοῦ τὸ θηρίον
ἐκόμισεν ἔμπνουν εἰς Μυκήνας.

Pindar, *Olympian Odes* 10, 27-30

πέφνε Κτέατον ἀμύμονα, 27
πέφνε δ' Εὔρυτον, ὡς Αὐγέαν λάτριον
ἀέκονθ' ἑκὼν μισθὸν ὑπέρβιον
πράσσοιτο 30

Euripides, *Alcestis* 479 ff.

Χο. ἀλλ' εἰπὲ χρεία τίς σε Θεσσαλῶν χθόνα
 πέμπει, Φεραῖον ἄστυ προσβῆναι τόδε. 480
Ηρ. Τιρυνθίῳ πράσσω τιν' Εὐρυσθεῖ πόνον.
Χο. καὶ ποῖ πορεύῃ; τῷ προσέζευξαι πλάνῳ;
Ηρ. Θρηκὸς τέτρωρον ἅρμα Διομήδους μέτα.
Χο. πῶς οὖν δυνήσῃ; μῶν ἄπειρος εἶ ξένου;
Ηρ. ἄπειρος· οὔπω Βιστόνων ἦλθον χθόνα. 485
Χο. οὐκ ἔστιν ἵππων δεσπόσαι σ'ἄνευ μάχης.
Ηρ. ἀλλ' οὐδ' ἀπειπεῖν μὴν πόνους οἷόν τ' ἐμοί.
Χο. κτανὼν ἄρ' ἥξεις ἢ θανὼν αὐτοῦ μενεῖς.
Ηρ. οὐ τόνδ' ἀγῶνα πρῶτον ἂν δράμοιμ' ἐγώ.
Χο. τί δ' ἂν κρατήσας δεσπότην πλέον λάβοις; 490
Ηρ. πώλους ἀπάξω κοιράνῳ Τιρυνθίῳ.
Χο. οὐκ εὐμαρὲς χαλινὸν ἐμβαλεῖν γνάθοις.
Ηρ. εἰ μή γε πῦρ πνέουσι μυκτήρων ἄπο.
Χο. ἀλλ' ἄνδρας ἀρταμοῦσι λαιψηραῖς γνάθοις.
Ηρ. θηρῶν ὀρείων χόρτον, οὐχ ἵππων, λέγεις.
Χο. φάτνας ἴδοις ἂν αἵμασιν πεφυρμένας.

Sophocles, *Trachiniae* 1089 ff.

 ὦ χέρες χέρες,
ὦ νῶτα καὶ στέρν', ὦ φίλοι βραχίονες, 1090
ὑμεῖς ἐκεῖνοι δὴ καθέσταθ', οἵ ποτε
Νεμέας ἔνοικον, βουκόλων ἀλάστορα,
λέοντ', ἄπλατον θρέμμα κἀπροσήγορον,
βίᾳ κατειργάσασθε, Λερναίαν θ' ὕδραν,
διφυῆ τ' ἄμεικτον ἱπποβάμονα στρατὸν 1095
θηρῶν, ὑβριστήν, ἄνομον, ὑπέροχον βίᾳ,
Ἐρυμάνθιόν τε θῆρα, τόν θ' ὑπὸ χθονὸς
Ἅιδου τρίκρανον σκύλακ', ἀπρόσμαχον τέρας,
δεινῆς Ἐχίδνης θρέμμα, τόν τε χρυσέων
δράκοντα μήλων φύλακ' ἐπ' ἐσχάτοις τόποις. 1100

Euripides, *Heracles* 360 ff.

πρῶτον μὲν Διὸς ἄλσος
ἠρήμωσε λέοντος 360
πυρσῷ δ'ἀμφεκαλύφθη
ξανθὸν κρᾶτ' ἐπινωτίσας
δεινῷ χάσματι θηρός·
τὰν τ' ὀρεινόμον ἀγρίων
Κενταύρων ποτὲ γένναν 365
ἔστρωσεν τόξοις φονίοις,
ἐναίρων πτανοῖς βέλεσιν.
ξύνοιδε Πηνειὸς ὁ καλ-
λιδίνας μακραί τ' ἄρου-
ραι πεδίων ἄκαρποι
καὶ Πηλιάδες θεράπναι 370
σύγχορτοί τ' Ὁμόλας ἔναυ-.
λοι, πεύκαισιν ὅθεν χέρας
πληροῦντες χθόνα Θεσσαλῶν
ἱππείαις ἐδάμαζον.
τὰν τε χρυσοκάρανον 375
δόρκαν ποικιλόνωτον
συλήτειραν ἀγρωστᾶν
κτείνας, θηροφόνον θεὰν
Οἰνωᾶτιν ἀγάλλει·
τεθρίππων τ'ἐπέβα 380
καὶ ψαλίοις ἐδάμασε πώλους
Διομήδεος, αἳ φονίαισι φάτναις ἀχάλιν' ἐθόα-
ζον κάθαιμα σῖτα γένυσι,
χαρμοναῖσιν ἀνδροβρῶσι
δυστράπεζοι· πέραν δ' 385
ἀργυρορρύτων Ἕβρου
διεπέρασεν ὄχθων,
Μυκηναίῳ πονῶν τυράννῳ.
ἄν τε Πηλιάδ' ἀκτὰν
Ἀναύρου παρὰ πηγὰς 390
Κύκνον ξεινοδαΐκταν
τόξοις ὤλεσεν, Ἀμφαναί-
ας οἰκήτορ' ἄμεικτον·
ὑμνῳδούς τε κόρας
ἤλυθεν ἑσπέριον ἐς αὐλάν, 395
χρυσέων πετάλων ἄπο μηλοφόρον χερὶ καρπὸν ἀμέρ-
ξων, δράκοντα πυρσόνωτον,
ὃς <σφ'> ἄπλατον ἀμφελικτὸς
ἕλικ' ἐφρούρει, κτανών·
ποντίας θ'ἁλὸς μυχοὺς 400
εἰσέβαινε, θνατοῖς
γαλανείας τιθεὶς ἐρετμοῖς·

οὐρανοῦ θ'ὑπὸ μέσσαν
ἐλαύνει χέρας ἕδραν,
Ἄτλαντος δόμον ἐλθών 405
ἀστρωπούς τε κατέσχεν οἴ-
κους εὐανορίᾳ θεῶν·
τὸν ἱππευτάν τ' Ἀμαζό-
νων στρατὸν Μαιῶτιν ἀμφὶ
πολυπόταμον ἔβα δι' Ἄ- 410
ξεινον οἶδμα λίμνας,
τίν' οὐκ ἀφ' Ἑλλανίας
ἄγορον ἁλίσας φίλων,
κόρας Ἀρείας πέπλων
χρυσεόστολον φάρος,
ζωστῆρος ὀλεθρίους ἄγρας. 415
τὰ κλεινὰ δ' Ἑλλὰς ἔλαβε βαρ-
βάρου κόρας λάφυρα, καὶ
σῴζεται Μυκήναις.
τάν τε μυριόκρανον
πολύφονον κύνα Λέρνας 420
ὕδραν ἐξεπύρωσεν,
βέλεσί τ' ἀμφέβαλ' ⟨ἰόν⟩,
τὸν τρισώματον οἷσιν ἔ-
κτα βοτῆρ' Ἐρυθείας.
δρόμων τ'ἄλλων ἀγάλματ' 425
εὐτυχῆ διῆλθε· τόν τε
πολυδάκρυον ἔπλευσ' ἐς Ἅι-
δαν, πόνων τελευτάν ...

Bibliography

Ancient Sources and Editions

Apollodorus, *The Library*, tr., Sir James George Frazer. London: W. Heinemann; N.Y.: G. P. Putnam's Sons, 1921.

Diodorus Siculus, tr., C. H. Oldfather. Cambridge, Mass.: Harvard University Press; London: W. Heinemann, Ltd., 1935.

Euripides. With an introduction by Richmond Lattimore. Chicago: The University of Chicago Press, 1955-59.

Euripides. *Alcestis*, tr., Richmond Lattimore. Chicago: The University of Chicago Press, 1955-59.

Euripides. *Herakles*, tr., William Arrowsmith. Chicago: The University of Chicago Press, 1955-59.

Hesiod. *Theogony*, tr., Richmond Lattimore. Ann Arbor: The University of Michigan Press, 1959.

The Odes of Pindar. 2nd ed., tr., Richmond Lattimore. Chicago: The University of Chicago Press, 1976.

Pindar's Odes. Tr., Roy Arthur Swanson. Indianapolis: Bobbs-Merrill, 1974.

Sophocles. *The Women of Trachis*, tr., M. Jameson, in *Sophocles* with an introduction by David Grene. Chicago: The University of Chicago Press, 1954-55.

Books with sections on or devoted to Heracles

Boardman, J. *Athenian Black Figure Vases*. New York: Oxford University Press, 1974.

Boardman, J. *Athenian Red Figure Vases: the Archaic Period*. London: Thames and Hudson, 1975.

Brommer, F. *Denkmälerlisten zur griechischen Heldensage* I. *Herakles*. Marburg: Elmert, 1971; hereafter Brommer *DL*.

Fittschen, K. *Untersuchungen zum Beginn der Sagen-darstellungen bei den Griechen*. Berlin: Hessling, 1969.

Flacelière, R. and Davambez, P. *Héraclès Images & Récits*. Paris: E. de Boccard, 1966.

Galinsky, G. Karl. *The Herakles Theme.* Oxford: Blackwell, 1972.

Schefold, K. *Götter und Heldensagen der Griechen in der spätarchaischen Kunst.* Munich: Hirmer, 1978; hereafter Schefold, *Götter.*

———. *Die Göttersage in der klassischen und hellenis-tischen Kunst.* Munich: Hirmer, 1981.

Schwarz, S.J. "The Iconography of the Archaic Etruscan Herakles: a Study of Three Adventures; Nessos, Pholos and Acheloos." Diss.: University of Maryland, 1974.

Stern, F.V.K., ed. *The Labors of Herakles on Antiquities from West Coast Collections.* Eugene, Or.: University of Oregon Press, 1976.

———. "Tradition and Invention in the Iconographic Program of the Early Archaic Temple in the Hera Sanctuary at Foce del Sele." Diss.: Brown University, 1973.

Steuben, H. von. *Frühe Sagendarstellungen in Korinth und Athen.* Berlin: Hessling, 1968.

Woodward, S. "Exemplum Virtutis: A Study of Heracles in Athens in the Second Half of the Fifth Century B.C." Diss.: Columbia University, 1966.

Books and Articles on the Labors

1. The Nemean Lion

Bendinelli, G. "Studi intorno ai frontoni arcaici ateniesi: II Eracle e il leone nemeo." *Ausonia* 10 (1921): 131 ff.

Boardman, J. "Herakles, Peisistratos and Eleusis." *JHS* 95 (1975): 1 ff.

Brommer, F. *DL:* 102 ff.

———. *VL³:* 109 ff.

Kunze, E. *Schildb.* 95 ff.

Kunzl, E. "Frühellenistische Gruppen." Diss.: 1968: 70 ff.

Luce, S.B. "List of Vases Showing Heracles and the Nemean Lion." *AJA* 20 (1916): 460-73.

Marwitz, H. "Zur Einheit des Andokidesmalers." *JdI* 46 (1961-63): 76 ff.

Salis, A. v. "Lowenkampbilder des Lysipp." 112 *BWPr* (1956): 5 ff.

Schefold, K. *Götter:* 90 ff.

Steuben, H. von. *Frühe Sagendarstellungen in Korinth und Athen.* Berlin: Hessling, 1968: 17ff., 112f.

Stibbe, C.M. *Lakonische Vasenmaler des sechsten Jahrhunderts v. Chr.* Amsterdam: North Holand, 1972: 250.

Zancani Montuoro, P. and Zanotti-Bianco, U. *Heraion alla Foce del Sele,* II. Rome: Libreria della Stato, 1954: 196 ff.

2. The Lernian Hydra

Amandry, P. "Skyphos corinthien du Musée du Louvre." *MonPiot* 40 (1944): 23 ff.

_____. "Hérakles et l'hydre de Lerne." *Bull. fac. des lettres Strasbourg* 30 (1952): 293· ff.

Bizi, A. "L'idra: antecedenti figurativi orientali." *MélCarthage* (1964/65): 21 ff.

Brommer, F. *DL*: 77 ff.

_____. "Herakles und Hydra auf attischen Vasenbildern." *MarbWPr* (1949): 3 ff.

_____. *VL³*: 79 ff.

Fittschen, *Untersuchungen*: 147 ff.

Rumpf, A. S.v. idra. *EAA IV* (1961): 90 ff.

Schauenburg, K. "Herakles und die Hydra auf attischem Schalenfuss." *AA* (1971): 162 ff.

Schefold, K. *Götter*: 95 ff.

Von Steuben, H. *Frühe Sagendarstellungen in Korinth und Athen*: 19 ff.; 113.

3. The Erymanthian Boar

Luce, S.B. "Studies of the Exploits of Heracles on Vases: Heracles and the Erymanthian Boar." *AJA* 28 (1924): 296 ff.

Amandry, P. "Héraklès, Eurysthée et le sanglier d'Erymanthe sur deux appliques de bronze trouvées à Delphes." *BCH* 66-67 (1942-43): 150 ff.

Brommer, F. *DL*: 40 ff.

_____. *VL³*: 47 ff.

Zancani Montuoro, P. and Zanotti-Bianco, U. *Heraion alla Foce del Sele*. Vol. 2. Rome: Libreria dello Stato, 1954: 196 ff.

4. The Ceryneian Hind

Albizzati, C. *Due nuovi acquisti del Museo Gregoriano-Etrusco*. Vatican City: Vatican, 1929: 7 ff.

Brommer, F. *DL*: 70 ff.

_____. "Herakles un die Hirschkuh." *AA* (1977): 479 ff.

_____. "Mythologische Darstellungen auf Vasenfragmenten der Sammlung Cahn." *AntK, Suppl.* 7: 51 ff.

_____. *VL³*: 75 ff.

R. Hampe, *Frühgriechische Sagenbilder in Böotien*. Athens: Deutsches archäologisches institut, 1936: 42 ff.

Kenner, H. "Amphorareste im Stil des Oltos." *JhÖ* 28 (1933): 41 ff.

Lezzi-Hafter, A. "Ein Frühwerk des Eretriamalers." *AntK* 14 (1971): 84 ff.

Meule, K. "Scythica Vergiliana. 4. Herakles und die Kerynitische Hindin." *Schweizerisches Archiv für Volkskunde* 56 (1960): 125 ff.

Schefold, K. *Götter*: 100 ff.

5. The Stymphalian Birds

Brommer, F. *DL*: 165 ff.

_____. *VL³*: 207 ff.

Luce, S.B. "List of Vases Showing the Killing of the Stymphalian

Birds." *AJA* 20 (1916): 473 ff.

Hampe, R. *Frühgriechische Sagenbilder in Böotien:* 42 ff.

Haspels, E. *ABL:* 27.

Schefold, K. *Götter:* 102 ff.

6. The Stables of Augeas

Brommer, F. *DL:* 33 ff.

Squarciapino, M.F. "Ercole e le stalle di Augia in un emblema ostiense." *ArchCl* 10 (1958): 106 ff.

7. The Cretan Bull

Borbein, A.H. "Campanareliefs." *RM* 14 (1968): 172 ff.

Brommer, F. *DL:* 156 ff.

———. *VL³:* 194 ff.

Hausmann, U. "Herakles und Theseus im Stierkampf," in *Hellenistische Reliefbecher aus attischen und böotischen Werkstätten.* Stuttgart: W. Kohlhammer, 1959: 69 ff.

Robertson, M. "Europa," *Journal of the Warburg and Courtauld Institutes* 20 (1957): 1 ff.

Schefold, K. *Götter:* 103 ff.

8. The Thracian Horses

Brommer, F. *DL:* 145 ff.

———. *VL³:* 186 ff.

Kurtz, D. "The Man-Eating Horses of Diomedes." *JHS* 95 (1975): 171 ff.

Lacroix, L. *Études d'archéologie numismatique.* Paris: de Boccard 1974: 80 ff.

Preller-Robert²: 458 ff.

Schefold, K. *Götter:* 104 ff.

9. The Amazons

Bothmer, D. von. *Amazons in Greek Art.* Oxford: Clarendon Press, 1957.

Brommer, F. *DL:* 20 ff.

———. *VL³:* 7 ff.

FR II: 1 ff.

Fittschen, K. *Untersuchungen:* 147 ff.

Schauenburg, K. "Die Gürtel der Hippolyte." *Philologus* 104 (1960): 1 ff.

Schefold, K. *Götter:* 105 ff.

Thomas, E. "Mythos und Geschichte." Ph.D. dissertation, Cologne, 1976: 35 ff.

10. Geryon

Brize, P. "Die Geryoneis des Stesichorus und die frühe griechische Kunst." *Beiträge zur Archäologie* 12 (1980).

Brommer, F. *DL:* 49 ff.

———. *VL³:* 58 ff.

Clement, P.A. "Geryon and others in Los Angeles," *Hesperia* 24 (1955): 1 ff.

Croon, J. *The Herdsman of the Dead.* Utrecht: H. de Vroede, 1952: 93 ff.

Fittschen, K. *Untersuchungen*: 147 ff.

Neutsch, B. "Eine Amphora der Werkstatt des Exekias." *Ganymed* (1949): 29 ff.

Robertson, M. "Geryoneis: Stesichorus and the Vase Painters." *ClQ* 19 (1969): 207 ff.

Rumpf, A. S.v. Gerioneo. *EAA III* (1960): 845 ff.

Schefold, K. *Götter*: 113 ff.

11. Cerberus

Boardman, J. "Herakles, Peisistratos and Eleusis." *JHS* 95 (1975): 1 ff.

Brommer, F. *DL*: 92 ff.

———. "Mythologische Darstellungen auf Vasenfragmenten der Sammlung Cahn." *AntK*, Suppl. 7: 51 ff.

———. F. *VL³*: 91 ff.

Davies, M.I. "Herakles and Kerberos. On Confronting Vicious Dogs." AIA Abstracts in *AJA* 81 (1977): 239.

Pinney, G. and Ridgway, B.S. "Herakles at the Ends of the Earth." *JHS* 101 (1981): 141 ff.

Preller-Robert ², 483 ff.

Roux, G. "Héraklès et Cerbère sur une amphore du Louvre." *Mélanges d'archéologie et d'histoire offerts à Charles Picard* (1949): 896 ff.

Schauenburg, K. "Eine neue Amphora des Andokidesmaler." *JdI* 76 (1961): 60 ff.

Schmidt, M. "Zur Deutung der 'Dreifuss-Metope' on Foce del Sele." In *Festschrift für Frank Brommer* (1977) n. 154

Sgatti, G. S.v. Cerbero. *EAA II*, (1959): 505 ff.

Schefold, K. *Götter*: 120 ff.

Sourvinon-Inwood, C. "Three Related Cerberi," *AntK* 17 (1974): 30 ff.

12. The Hesperides

Beckel, G. *Götterbeistand in der Bildüberlieferung griechischer Helden-sagen* (1961) 58

Brommer, F. *DL*: 59 ff.

———. S.v. Esperidi. *EAA III* (1960): 443 ff.

———. "Herakles und die Hesperiden auf Vasenbildern." *JdI* 57 (1942): 105 ff.

———. *VL³*. 71 ff.

Fürtwangler, A and Reichhold, K. *Griechische Vasenmalerei*, ser. I. Munich: Bruckman, (1904): 42 ff.

Götze, H. "Die attischen Dreifigurenreliefs." *RM* 53 (1938): 220 ff.

———. "Die Deutung des Hesperidenreliefs." *JdI* 63-64 (1948-49): 91 ff.

Greifenhagen, A. *Neue Fragmente des Kleophradesmalers.* Heidelberg: C. Winter, 1972.

Harrison, E.B. "Hesperides and Heroes: a Note on the Three-Figure Reliefs." *Hesperia* 33 (1964): 76 ff.

Jucker, H. "Herakles und Atlas auf einer Schale des Nearchos in Bern." *Festschrift für Frank Brommer* (1977): 191 ff.

Metzger, H. *Les représentations dans la céramique attique du* IVe *Siècle,* Bibliothèque des Écoles françaises d'Athènes et du Rome. Paris: de Boccard, 1951: 202 ff.

Preller-Robert [2]: 488.

Schefold, K. *Götter:* 123 ff.

Von Steuben, H. *Frühe Sagendarstellungen in Korinth und Athen:* 32 ff.

Turner, E.G. "Papyrus Bodmer XXVII: A Satyr-Play on the Confrontation of Heracles and Atlas." Mus Helv 33 (1976): 1 ff.

Abbreviations

The abbreviations conform in general to those found in the *American Journal of Archaeology* 82 (1978) 5-10.

AA	*Archäologischer Anzeiger*
Abh Berl Ak	*Abhandlungen der Berliner Akademie*
ABV	J. D. Beazley, *Attic Black-figure Vase-Painters,* 1956
AJA	*American Journal of Archaeology*
Akrop. Vas.	B. Graef and E. Langlotz, *Die antiken Vasen von der Akropolis zu Athen,* 1929-1933
AM	*Mitteilungen des Deutschen Archäologischen Instituts: Athenische Abteilung*
AntCl	*L'Antiquité Classique*
AntK	*Antike Kunst*
AntPl	*Antike Plastik*
Arch Cl	*Archeologia Classica*
ASAtene	*Annuario della R. Scuola Archeologia di Atene*
Ashmole, *Architect*	B. Ashmole, *Architect and Sculptor in Classical Greece,* 1972
AttiAcc Lincei	Accademia nazionale dei Lincei, Rome. *Atti*
AZ	*Archäologische Zeitung*
BCH	*Bulletin de Correspondance Hellénique*
Boll. d'Arte	*Bolletino d'Arte*
Beazley, *Development*	J.D. Beazley, *The Development of Attic Black-figure,* 1951
Brommer *DL*	F. Brommer, *Denkmälerlisten zur griechischen Heldensage. I. Herakles,* 1971.
Brommer *VL*[3]	F. Brommer, *Vasenlisten zur griechischen Heldensage,* 3rd ed., 1973
BSA	*Annual of the British School at Athens*
BVAB	*Bulletin van de Vereeniging tot Bevordering der Kennis van de Antieke Beschaving*
BWPr	*Winckelmannsprogramm der Archäologischen Gesellschaft zu Berlin*

CahArch	*Cahiers Archéologiques. Fin de l'antiquité et moyen âge*
ClQ	*Classical Quarterly*
Cook, *Zeus*	A. B. Cook, *Zeus: a Study in Ancient Religion,* Vols. I-III, 1914-1940
CR	*Classical Review*
Critd'Arte	*La Critica d'arte; rivista bimestrale di arti figurative*
Curtius, *Interpretationen*	L. Curtius, *Interpretationen von sechs griechischen Bildwerken,* 1947
CVA	*Corpus Vasorum Antiquorum*
EAA	*Enciclopedia dell'arte antica, classica e orientale,* 1958-1973
Ephem	*Ephémeris archaiologiké*
EVP	J. D. Beazley, *Etruscan Vase-Painting,* 1947
FdD	*Feuilles de Delphes*
FGH	C. Müller, *Fragmenta Historicorum Graecorum,* 1841-70
Fittschen, *Untersuchungen*	K. Fittschen, *Untersuchungen zum Beginn der Saendarstellungen bei den Griechen,* 1969
Fröber	J. Frober, *Die Komposition der archaischen und Frühklassischen griechischen Metopenbilder,* n. d.
Furtwängler *AG*	A. Furtwängler, *Die antiken gemmen; geschichte der steinschneidekunst im klassischen altertum,* 1900
GGA	*Göttingische Gelehrte Anzeigen*
Gymn	*Gymnasium*
Hampe, *Sagenbilder*	R. Hampe, *Frühe griechische Sagenbilder in Böotien,* 1936
Haspels, *ABL*	C. H. E. Haspels, *Attic Black-figured Lekythoi,* 1936
Helbig[4]	W. Helbig, *Führer durch die öffentlichen Sammlungen Klassischen Altertümer in Rom,* 4th ed., 1963-1972
JdI	*Jahrbuch des Deutschen Archäologischen Instituts*
JHS	*Journal of Hellenic Studies*
JhÖ	*Jahreshefte des Österreichischen Archäologischen Instituts*
KlPauly	*Der Kleine Pauly; Lexikon der Antike.* K. Ziegler and W. Sontheimer, eds. 1964-
Krauskopf, *Sagenkreis*	I. Krauskopf, *Der thebanische Sagenkreis und andere griechische Sagen in der etruskischen Kunst,* 1974
Kunze, *Schildb.*	E. Kunze, *Archaische Schildbänder, Olympischer Forschungen* 2, 1950

Langlotz-Schuchhardt	E. Langlotz and W. H. Schuchhardt, *Archaische Plastik auf der Akropolis,* 1941
Liddell-Scott	H. G. Liddell and R. Scott, *A Greek-English Lexicon,* rev. H. Stuart Jones, 1940
MarbWPr	Marburger Winckelmann-Programm
Mau, v. Mercklin, Matz	A. Mau, *Kataloge der bibliothek des Deutschen archäologischen Instituts Rom,* ed. E. v. Mercklin and F. Matz, 1932
MdI	*Mitteilungen des Deutschen Archäologischen Instituts,* 1948-52
Mélanges Picard	*Mélanges d'archéologie et d'histoire offerts à Charles Picard...,* 1949
Mingazzini	P. Mingazzini, *Le rappresentazioni vascolari del mito dell' apoteosi di Herakles...,* 1925
ML	See Roscher
MonPiot	*Monuments et mémoires... l'Académie des inscriptions et belles lettres,* Fondation Piot
Mus Helv	Museum Helveticum. *Revue Suisse pour l'Étude de l'Anti quité classique*
NSc	*Notizie degli Scavi di Antichità*
OpRom	*Opuscula romana*
Overbeck, *Schriftquellen*	J. Overbeck, *Die antiken Schriftquellen zur geschichte der bildenden Kü*nste bei den Griechen, 1959
Payne, *NC*	H. G. G. Payne, *Necrocorinthia, a Study of Corinthian Art in the Archaic Period,* 1955
Payne-Young	See *Perachora*
Perachora	T. J. Dunbabin, *Perachora,* 1955
Pfuhl, *MuZ*	E. Pfuhl, *Malerei und Zeichnung der Greichen,* 1923
Preller-Robert²	L. Preller, *Griechische Mythologie,* 2nd. ed., C. Robert, 1894–
Preller-Robert⁴	L. Preller, *Griechische Mythologie,* 4th ed., C. Robert, 1894–
RA	*Revue archéologique*
RE	Pauly-Wissowa, *Real-Encyclopädie der klassischen Altertumswissenschaft*
RBPhil	*Revue Belge de Philologie et d'Histoire*
RM	*Mitteilungen des Deutschen Archäologischen Instituts: Römische Abteilung*
Roscher	W. H. Roscher, ed., *Ausführliches Lexikon der griechischen und römischen Mythologies,* 1884-1937
Rumpf, *Chalk Vasen*	A. Rumpf, *Chalkidische Vasen,* 1927
Schauenburg, *Jagd*	K. Schauenburg, *Jagddarstellungen in der griechischen Vasenmalerei,* 1969
Simon, *Götter*	E. Simon, *Die Götter der Griechen,* 1969

Sb	*Sitzungsberichte* (followed by name of academy)
StEtr	*Studi Etruschi*
Weitzmann, *Mythology*	K. Weitzmann, *Greek Mythology in Byzantine Art*, 1951
Winter, *KiB*	F. Winter, ed., *Kunstgeschichte in Bildern*, 5 vols., 1898-1902
ZfN	*Zeitschrift für Numismatik*

Index

Acarnia, 60
Achilles: as fighter of Amazons, 37
Acropolis, the, 16, 66, 47
Acusilaus, 56
Alcestis (Euripides), 63, 34-35
Alcmene, 3, 4
Alpheus (river), 29, 30
Alyzis, 60
Amazons, The (Heraclean labor), 34-40;
 belt motif in, 37-40; depiction of, on
 artifacts, 37-39, 38 (illus.), 57; depic-
 tion of, in literature, 37, 62-63; depic-
 tion of, on monuments, 39-40, 59; ear-
 liest evidence for, 55-56
Amphanaia, 62
Amphitryon, 3-4
Amyclae, throne of (Sparta), 57; depic-
 tion of Apples of Hesperides labor on,
 52; depiction of Cerberus labor on, 47;
 depiction of Geryon labor on, 42;
 depiction of Nemean Lion labor on,
 10; depiction of Thracian Horses
 labor on, 36
Anauros, 62
Andromache: in Amazons labor, 39
Andromeda: in Amazons labor, 38
Antaeus, 64
Apollo: depiction of, on monuments, 59;
 in Ceryneian Hind labor, 22-24; in
 quarrel over Delphic tripod, 24, 59
Apollo from Veii (terracotta group), 24
Apollodorus: Amazons labor in writings
 of, 37; Apples of Hesperides labor in
 writings of, 49; Cerberus labor in
 writings of, 45-46, 47; Ceryneian Hind
 labor in writings of, 22, 24; Lernian
 Hydra labor in writings of, 18; Stables
 of Augeas labor in writings of, 29;
 Stymphalian Birds labor in writings
 of, 26; Thracian Horses labor in writ-
 ings of, 35
Apollonius, 64

Apollonius Rhodius: Amazons labor in
 writings of, 37
Apples of the Hesperides, The (Hera-
 clean labor), 49-53; depiction of, on
 artifacts, 50-52, 51 (illus.); depiction
 of, in literature, 49-50, 60-63, 64;
 depiction of, on monuments, 52, 53
 (illus.), 60; earliest evidence of, 55-56
Ares, 66
Aristocles, 39
Artemis, 62; in Ceryneian Hind labor,
 21-24
Artemis, temple of (Stymphalus): depic-
 tion of the Stymphalian birds on, 28
Artemisius (mountain), 22
Athena: in Apples of the Hesperides
 labor, 53; in Cerberus labor, 45-46; in
 Ceryneian Hind labor, 23-24; in Gery-
 on labor, 42-43; in Lernian Hydra
 labor, 12, 14-15; in Stables of Augeas
 labor, 30; in Stymphalian Birds labor,
 27
Athena Chalkiokos (Sparta): depiction
 of Heracles' deeds on, 57
Athene. *See* Athena
Athenian treasury (Delphi), 58-59; de-
 piction of Amazons labor on, 39;
 depiction of Ceryneian Hind labor on,
 24-25, 42; depiction of Geryon labor
 on, 42; depiction of Lernian Hydra
 labor on, 17; depiction of the Nemean
 Lion labor on, 10, 42; depiction of the
 Stymphalian Birds labor on, 28; depic-
 tion of Theseus' deeds on, 58; depic-
 tion of the Thracian Horses labor on,
 36
Athens, 6, 19, 58, 66
Atlas: in Apples of the Hesperides labor,
 49-53; depictions of, on monuments,
 59; depictions of, in literature, 61-62
Augeas, King: in Stables of Augeas labor,
 29-30

Bacchylides, 56
Beard: as attribute of hero, 66
Bellerophon: as fighter of Amazons, 37
Belt of the Amazons. *See* Amazons
Bistones, 34
Boar hunts, 20
Boethius, 64
Bow: as hero's weapon, 65-66
Bulls: in Greek myths, 31

Canonic deeds of Heracles. *See* Dodekathlos, the
Centaur (non-canonic Heraclean labor): depictions of, in literature, 60-61, 64; depictions of, on monuments, 58
Cerberus (Heraclean labor), 42, 45-48; depiction of, on artifacts, 46-47; depiction of, in literature, 45-46, 60-63; depiction of, on monuments, 47-48; earliest evidence for, 55-56; number of heads, 45
Ceryneian Hind, 21-25, 40; depiction of, on artifacts, 22-25, 23 (illus.); depiction of, in literature, 21-22, 24, 62, 64; depiction of, on monuments, 24-25, 42, 58, 60; earliest evidence for, 55-56
Cerynitian Hind. *See* Ceryneian Hind.
Ceto: in Apples of the Hesperides labor, 49
Club: as hero's weapon, 66
Corinth, 6, 13
Crab. *See* Lernian Hydra, crab motif in
Cretan Bull, 31-33; on artifacts, 31-32; depiction of, in literature, 31, 61, 64; depiction of, on monuments, 32-33; earliest evidence for, 55-56
Crete, 31
Crommyon, 20
Crommyonian sow: in Theseus legend, 20
Cronus, 5
Cycnus (non-canonic Heraclean labor): depiction of, on artifacts, 66; depiction of, in literature, 62; depiction of, on monuments, 58-59
Cypselus, chest of, 42, 57, 60; depiction of Apples of Hesperides labor on, 52
Cyrene, 52

Deeds of Heracles, canonic. *See* Dodekathlos, The
Delphi, 10, 16-17, 24-25, 36, 39, 42, 58-59
Delphi theater: depiction of Heracles' deeds on frieze of, 64

Diodorus: Amazons labor in writing in writings of, 37; Apples of the Hesperides labor in writings of, 49; Cerberus labor in writings of, 45-66; Ceryneian Hind labor in writings of, 21-22; Erymanthian Boar labor in writings of, 19; the Stables of Augeas labor in writings of, 29; the Thracian Horses labor in writings of, 35
Diomedes, 62; in Thracian Horses labor, 34-36
Dodekathlos, The: earliest evidence for each labor in, 55-56; first appearance of, as artistic theme, 5, 55, 59; frequency of appearance of, as artistic theme, 60, 64; origin and development of, 5, 55-64; sequence of twelve labors in, 58, 64; temple of Zeus as prototype for, 11, 55, 57, 59-60, 64. *See also* Heracles, deeds of
"Dodekathlos" (word): etymology of, 63

Ebros, 35
Echidna, 12, 45
Elis, 29
Epicharmus, 56; Amazons labor in writings of, 37
Epidamnians, treasury of: depiction of Apples of the Hesperides labor on, 52
Erymanthian Boar, 19-20; depiction of, on artifacts, 19, 46-47, 57; depiction of, in literature, 19, 60-61, 64; depiction of, on monuments, 19-20, 59; earliest evidence for, 55-56
Erymanthus mountains, 19
Erytheia, 41, 63
Etruria, 24
Euphronius, 15, 42
Euripides, 56, 59, 61-63; Amazons labor in writings of, 37; Apples of the Hesperides labor in writings of, 49; Cerberus labor in writings of, 45; Ceryneian Hind labor in writings of, 21-22; Geryon labor in writings of, 41; Thracian Horses labor in writings of, 34-35
Europa, 31
Eurystheus, King: in Apples of the Hesperides labor, 49; in Cerberus labor, 45-47; in Ceryneian Hind labor, 21-22; in Cretan Bull labor, 19, 31; depiction of, on temple of Zeus, 59; in Erymanthian Boar labor, 20, 59; in Geryon labor, 41; in Lernian Hydra labor, 59;

Eurystheus, King: (continued)
in Nemean Lion labor, 59; in Stables of Augeas labor, 29; in Stymphalian Birds labor, 26-27; in Thracian Horses labor, 34-35

Eurytion: in Geryon labor, 41-43

Excavations, German: in Olympia, 19

Fibulae: depicting Ceryneian Hind labor, 22; depicting Lernian Hydra labor, 13-14, 22; depicting Nemean Lion labor, 9; depicting Stymphalian Birds labor, 26

Foce del Sele, metopes of: depiction of Apollo on, 59; depiction of Erymanthian Boar labor on, 19

Geryon (Heraclean labor) 41-44, 45, depiction of, in literature, 63; depiction of, on monuments, 42-44, 58, 60; earliest evidence of, 55-56

Geryoneis (Stesichorus): Geryon labor in, 41-42

Hades, dog of. *See* Cerberus

Hades (god): in Cerberus labor, 46-47. *See also* Pluto

Hebe, 5

Hebros, 62

Hecataeus, 56

Hegylos, 52

Helios: in the Geryon labor, 44

Hellanicus, 56; Thracian Horses labor in writings of, 34

Hephaestus, temple of (Athens), 28, 33; depiction of Amazons labor on, 40; depiction of Apples of the Hesperides labor on, 54; depiction of Cerberus labor on, 48; depiction of Ceryneian Hind labor on, 25; depiction of Erymanthian Boar labor on, 19; depiction of Geryon labor on, 43-44; depiction of Lernian Hydra labor on, 17; depiction of Nemean Lion labor on, 11; depiction of Theseus' deeds on, 58-60; depiction of Thracian Horses labor on, 36

Hephaisteion. *See* Hephaestus, temple of (Athens)

Hera, 3; in Lernian Hydra labor, 12; in Thracian Horses labor, 35

Hera, temple of (Olympia). *See* Heraion

Heracles: ascent to Mount Olympus, 3, 5; deeds of, in Archaic art, 57-58; deeds of, on artifacts of minor art, 5-6; deeds of, depicted cyclically, 58-60; deeds of, in Homer's hymn to Heracles, 57; deeds

of, in juxtaposition with deeds of Theseus, 57, 60; deeds of, in literature, 3-5, 60-64; deeds of, on monuments, 3, 5-6, 57, 58-60; deeds of, predicted by Tiresias, 4-5; deeds of, in post-Hellenistic art, 64; deeds of, as inspiration to artists, 3, 5-6; deeds of, as theme in Classical and Hellenistic art, 6; deeds of, on vases, 58; image of, in transformation, 65-67; image of, as warrior, 65-66; parentage of, 3; in quarrel over Delphic tripod, 24, 59; region of his labors, 8 (map); statues of, 66. *See also* Dodekathlos, The

Heracles (Euripides), 59, 61-63; Amazons labor in, 37; Apples of the Hesperides labor in, 49; Cerberus labor in, 45; Ceryneian Hind labor in, 21; Geryon labor in, 41; Thracian Horses labor in, 35

Heracles from Aegina (pediment), 66

Heracles, temple of (Thebes): depiction of deeds of Heracles on, 60

Heraion: depiction of Apples of the Hesperides labor on, 52

Hermes: in Cerberus labor, 45-47

Hesiod, 56; Apples of the Hesperides labor in writings of, 49; Cerberus labor in writings of, 45; Geryon labor in writings of, 41; Lernian Hydra labor in writings of, 12

Hesione, 64

Hesperides: in Apples of the Hesperides labor, 49-52, 54

Hippolyte: in Amazons labor, 37-38, 40; in Apples of the Hesperides labor, 49

Homer, 56, 65; Cerberus labor in works of, 46; hymn to Heracles, 57

Homole, 61

Hydra, 45. *See also* Lernian Hydra

Illiad (Homer), 65; Cerberus labor in, 45

Iolaus, 36, 65; in Cretan Bull labor, 31; in Geryon labor, 42-43; in Stymphalian Birds labor, 26; in Lernian Hydra labor, 12-17; in Nemean Lion labor, 7-8

Ionia, 6

Iphicles, 3

Istria, 21

Kassel, 7

Labors of Heracles. *See* Dodekathlos, The; Heracles: deeds of

Ladon, 22

Leiria, 28, 30

Lerna (nymph): in Lernian Hydra labor, 15

Lerna (region), 12-13
Lernian Hydra, The (Heraclean labor), 12-18, 41; crab motif in, 12-17 passim; depiction of, on artifacts, 13-16, 14 (illus.), 16 (illus), 22, 50, 57, 66; depiction of, in Hellenistic and Imperial art, 17-18; depiction of, with human head, 17-18; depiction of, in literature, 12-13, 59-60, 63-64; depiction of, on monuments, 16-18, 17 (illus.), 43 63; earliest evidence for, 55-56; number of heads, 12-13; oriental prototypes as source for, 8-9, 12
Lion skin: as hero's attribute, 38, 65-66
Lucretius, 64
Lysippus, 30, 60

Maeotis, 63
Marathonian bull: in Theseus legend, 31
Meidias, 51
Minos, King, 31
Minotaur: depiction of, on monuments, 60, in Theseus legend, 31, 60
Mycenae, 22, 35, 37, 47, 49, 62-63
Myth, Greek: boar hunts in, 20; bulls in, 31; compared to allegory, fable, and fairy tale, 1; as form of expression, 1; function of, in ancient world, 1; study of, 1-2; as theme in Classical, Hellenistic and imperial art, 6

Nemea, 7
Nemean Lion, The (Heraclean labor), 7-11; depiction of, on artifacts, 7-10, 9 (illus.), 57; depiction of, in literature, 59-61; depiction of, on monuments, 10-11, 42, 51, 58; earliest evidence for, 55-56, oriental prototypes as source for, 8-9

Oceanus River, 41
Odyssey (Homer), 65; Cerberus labor in, 45
Oenoe, 22, 62
Oenoe, goddess of: in Ceryneian Hind labor, 21
Olympia, 10-11, 17, 19-20, 25, 27, 29, 36, 43, 48, 52; German excavations in, 19
Olympus, Mount: ascent of Heracles to, 3, 5
Orpheus: in Cerberus labor, 45
Orthus, 45; in Geryon labor, 41-43 passim

Panaenus, 60; Apples of the Hesperides labor in painting by, 54
Panyassis, 56

Pasiphae, 31
Pausanias, 10, 16, 28, 36, 39, 42, 47-48, 52, 53, 60
Pelion, Mount, 61, 62
Peneios, 61
Penthesilea, 37
Perachora, 40
Persephone, 45, 47
Pherae, 34
Pherecydes, 56; Apples of the Hesperides in writings of, 49
Phidias, 5
Phorcys: in Apples of the Hesperides, 49
Pindar, 3-5, 56, 64; Amazons labor in writings of, 37; Cerberus labor in writings of, 45; Ceryneian Hind labor in writings of, 21-22, 31; Geryon labor in writings of, 41; Stables of Augeas labor in writings of, 29, 30; Thracian Horses labor in writings of, 34
Pisander, 56
Pholus, 64
Plautus: Amazons labor in writings of, 37
Pluto: in Cerberus labor, 46. *See also* Hades (god)

Sea monsters: in non-canonic deeds of Heracles, 64
Selinus, 40
Septimius Severus, Basilica of (Leptis Magna): depiction of Heracles' deeds on pilaster reliefs of, 64
Silene (satyr): in Apples of the Hesperides, 50, 51 (illus.)
Siphnian treasury (Delphi), pediment of: depiction of Apollo on, 59; depiction of Heracles' deeds on, 59
Sophocles, 56; Apples of the Hesperides labor in writings of, 49; Cerberus labor in writings of, 45
Sparta, 6, 10, 57
Stables of Augeas, The (Heraclean labor), 29-30; depiction of, on artifacts, 29; depiction of, in literature, 29, 30, 61; depictions of, on monuments, 29-30, 64; earliest evidence for, 55-56
Stesichorus: Cerberus labor in writings of, 45; Geryon labor in writings of, 41, 42
Strabo, 60
Stymphalian Birds, The (Heraclean labor), 26-28, 40; depiction of, on artifacts, 26-27, 27 (illus.); depiction of, in literature, 26, 28, 30, 61; depiction of, on monuments, 27-28, 59; earliest evidence for, 55-56

Stymphalus, Lake, 26, 28

Sunium, 9, 36, 44, 60

Taygeta, 21

Theocles, 52

Theocritus, 64

Theogony (Hesiod), 12, 41, 45, 49

Theseion, 19

Theseus: in Crommyon sow legend, 20; deeds of, in Archaic art, 57-58; deeds of, depicted cyclically, 58-60; deeds of, in juxtaposition with deeds of Heracles, 57, 60; deeds of, on monuments, 58-60; deeds of, on vases, 58; in Marathonian bull legend, 31; in Minotaur legend, 31

Theseus, temple of (Athens). *See* Theseion

Thracian Horses, The (Heraclean labor), 34-36; depiction of, on artifacts, 35-36; depiction of, in literature, 34-36, 62; depictions of, on monuments, 36, 59, 60; earliest evidence for, 55-56

Tisagoras, 16

Trachiniae (Sophocles), 45, 49, 60-61

Tripod, Delphic, 24, 59

Twelve Labors of Heracles. *See* Dodekathlos, The

Vases, painted: depicting deeds of Heracles, 3, 6-8, 10, 13-16, 19, 22-27, 29, 31-32, 35-36, 38-42, 44, 46, 47, 50-52, 58, 67

Wild board hunts. *See* Boar hunts

Zeus, Temple of (Olympia): depiction of the Amazons labor on, 39-40; depiction of Cerberus labor on, 48; depiction of the Ceryneian Hind labor on, 25; depiction of the Cretan Bull labor on, 32-33; depiction of Dodekathlos on, 5, 55, 57, 59-60, 64, 67; depiction of the Erymanthian Boar labor on, 19-20; depiction of Geryon labor on, 43; depiction of Lernian Hydra labor on, 17, 43; depiction of Nemean Lion labor on, 10-11, 51; depiction of Stables of Augeas labor on, 29-30; depiction of Stymphalian Birds labor on, 27-28; depiction of the Thracian Horses labor on, 36

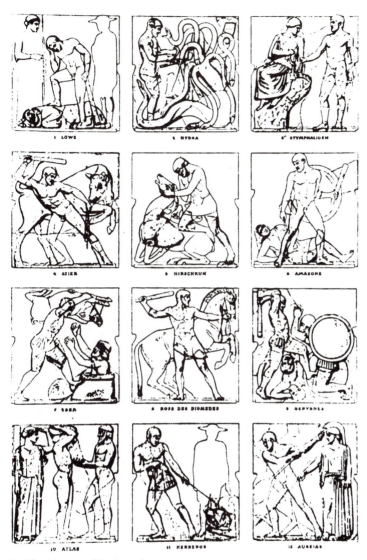

1. *The Metopes of the Temple of Zeus,* Olympia

2. *The Metopes: Hephaisteion, Athens*

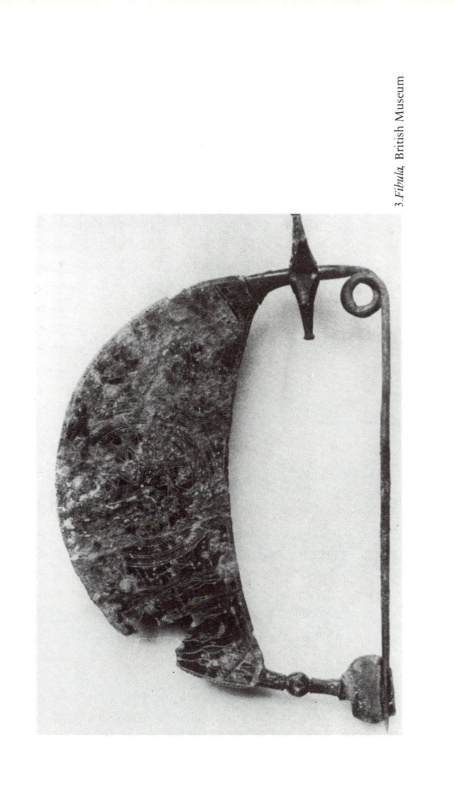

4.*Terracotta Stand, Cerameicus,* Athens

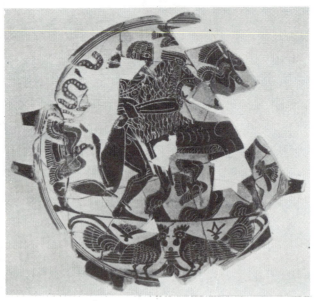

5.*Spartan Cup,* Museum, Samos

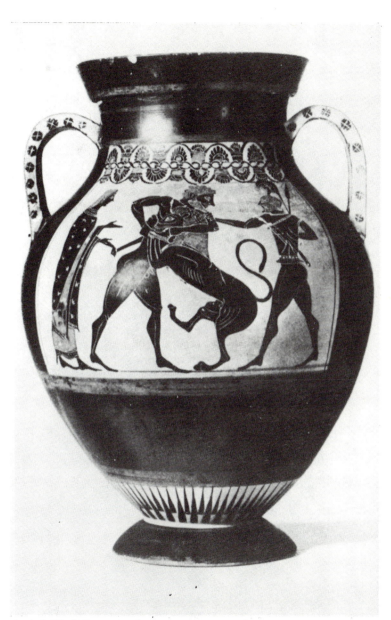

6. *Attic Black Figure Amphora,* Museum, Kassel

7. *Metope from Athenian Treasury,* Delphi

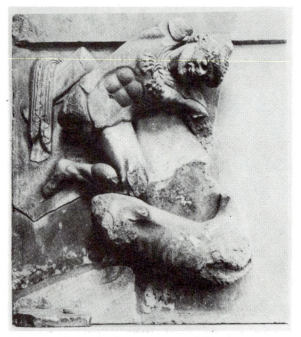

8. *Metope from Athenian Treasury,* Delphi

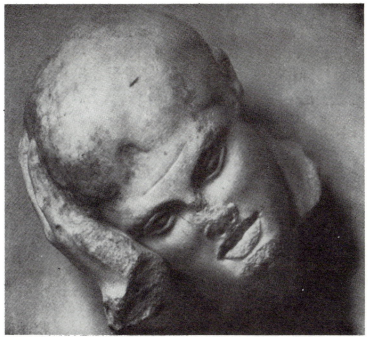

9. *Metope: Heracles Head,* Olympia

10. *Metope: Lion Head,* Olympia

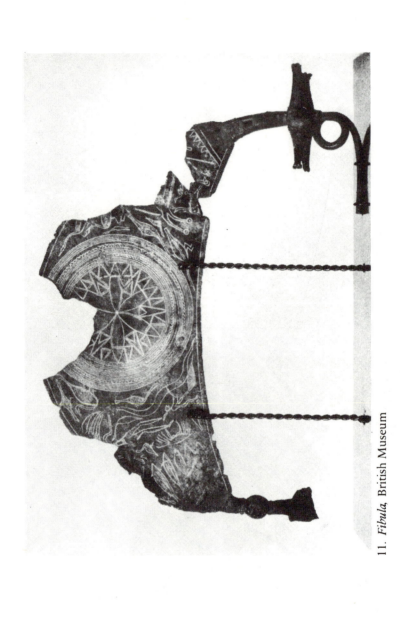

11. *Fibula*, British Museum

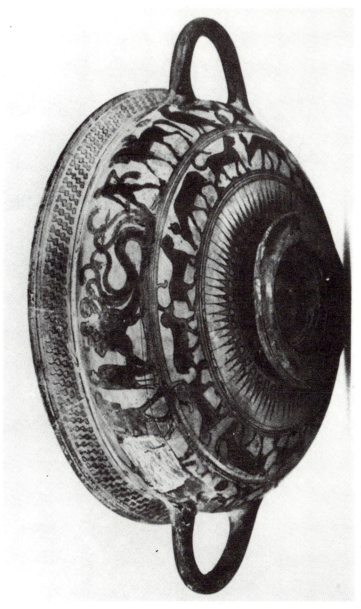

12. *Corinthian Cup, Jena*

13. *Attic Black Figure Cup,* Berlin

14. *Attic Red Figure Oinochoe,* Leningrad

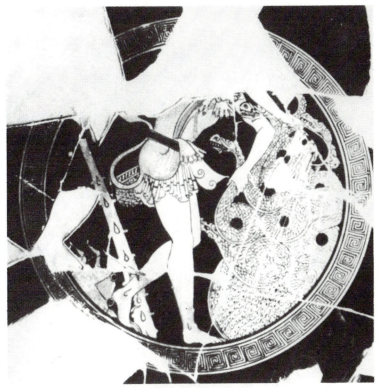

15. *Attic Red Figure Cup from the Acropolis,* Athens

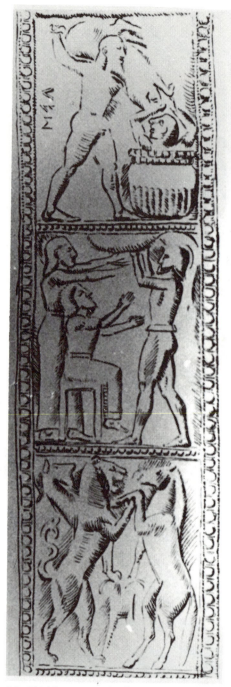

16 .*Shield Arm Band*, Olympia

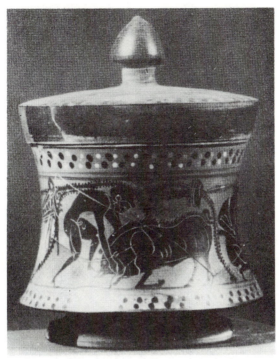

17. *Attic Black Figure Pyxis,* Berlin

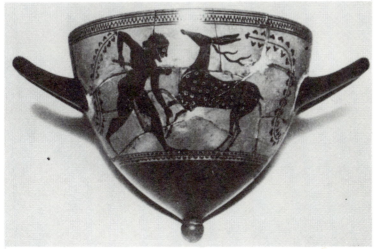

18. *Attic Black Figure Mastos,* Munich

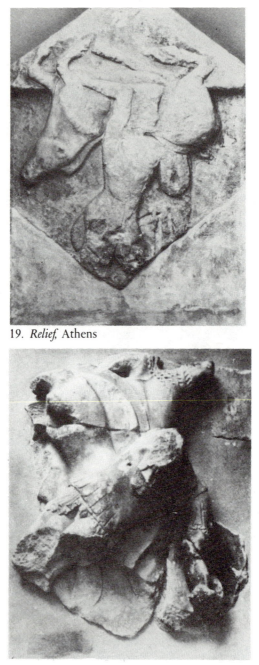

19. *Relief,* Athens

20. *Metope from Athenian Treasury,* Delphi

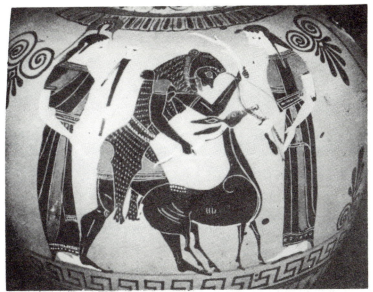

21. *Attic Black Figure Amphora*, British Museum

22. *Attic Black Figure Neck Amphora*, Würzburg

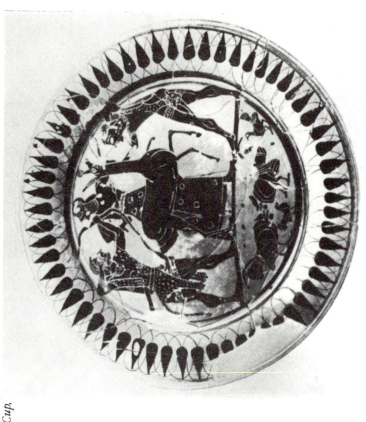

23. *Attic Black Figure Cup,*
Oxford

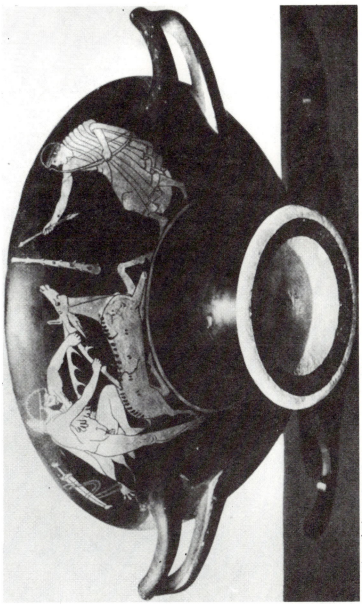

24. *Attic Red Figure Cup, Louvre.*

25. *Geometric Oinochoe*, Ny Carlsberg Glyptothek, Copenhagen

26. *Geometric Oinochoe*, Ny Carlsberg Glyptothek, Copenhagen

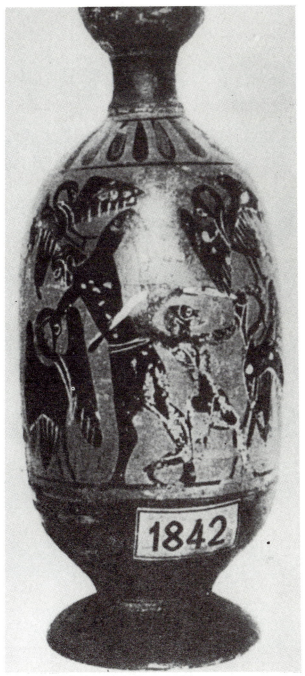

27. *Attic Black Figure Lekythos,* Munich

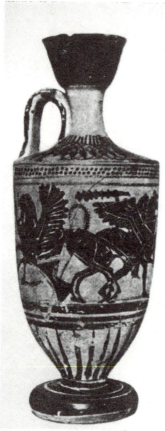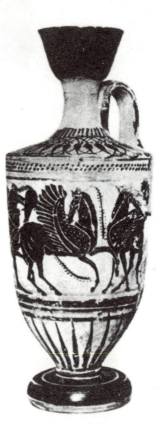

28. *Attic Black Figure Lekythos*, Syracuse

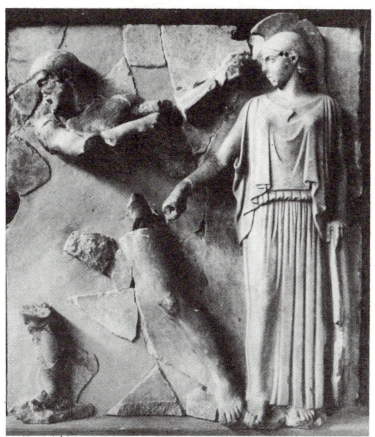

29. *Metope*, Olympia

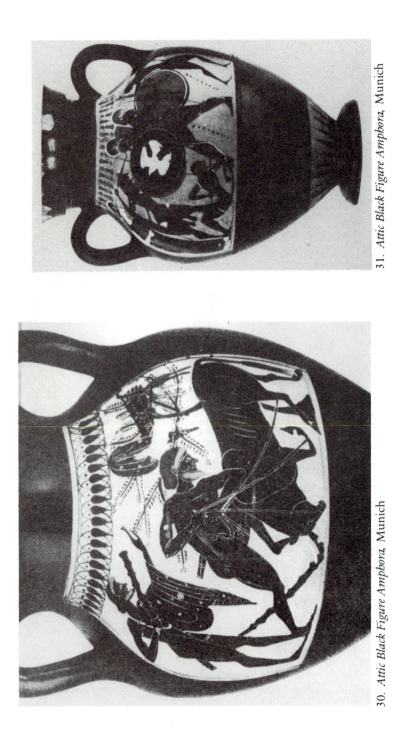

31. *Attic Black Figure Amphora, Munich*

30. *Attic Black Figure Amphora, Munich*

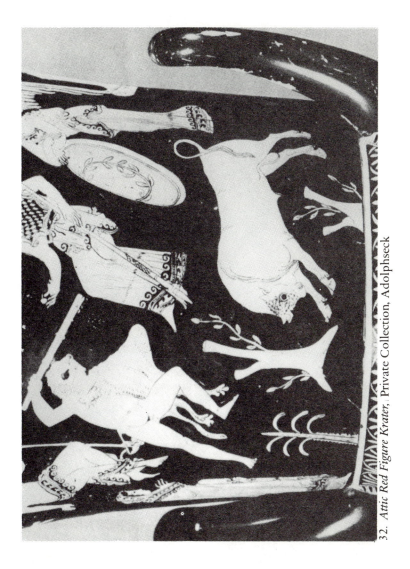

32. *Attic Red Figure Krater*, Private Collection, Adolphseck

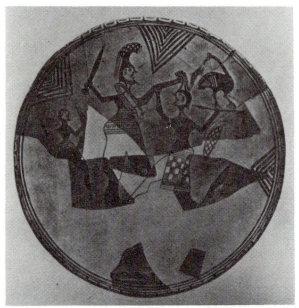

33. *Votive Shield from Tiryns,* Museum, Nauplia

34. *Attic Black Figure Amphora,* Berlin

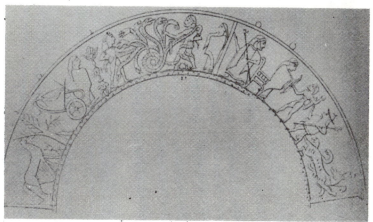

35. *Attic Red Figure Cup,* Berlin

36. *Corinthian Cup,* Location Unknown

37. *Proto-Corinthian Pyxis,* British Museum

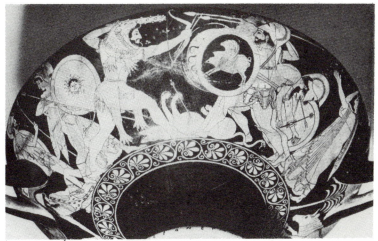

38. *Attic Red Figure Cup*, Munich

39. *Attic Red Figure Cup*, Munich

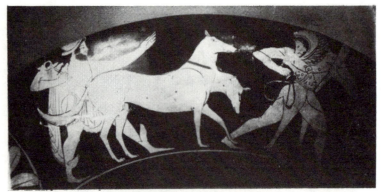

40. *Attic Red Figure Cup*, Würzburg

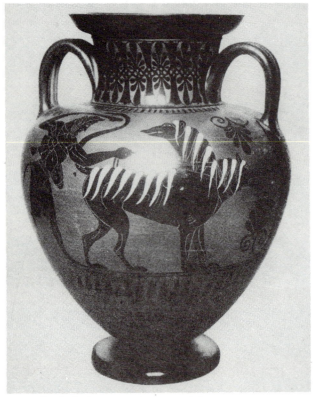

41. *Attic Black Figure Amphora*, Munich

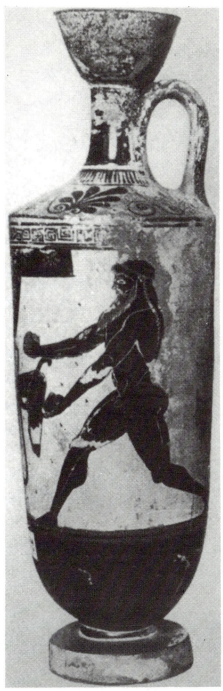

42. *Attic Black Figure Lekythos,* Athens

43. *Attic Black Figure Lekythos,* Berlin

44. *Attic Alabastron*, Museum, Nauplia

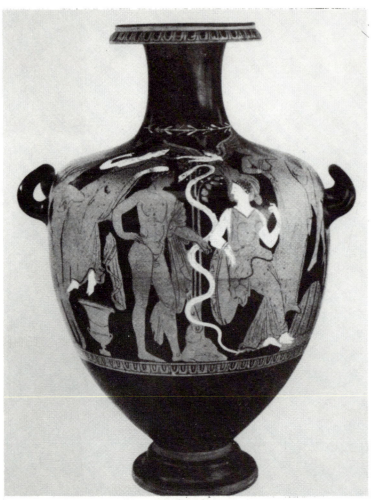

45. *Attic Red Figure Hydria,* Metropolitan Museum , New York

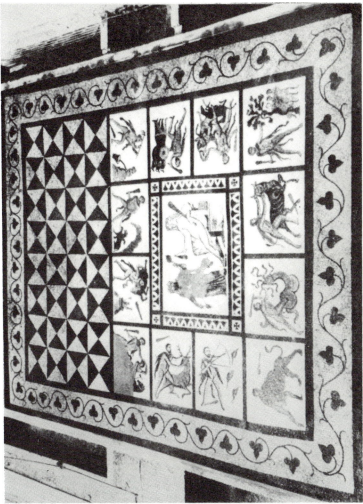

46. *Mosaic from Leiria*,
Museum, Madrid

47. *Heracles Head from "Olympus Pediment",* Acropolis Museum, Athens